Pictu. es from He. e
Sunil Gupta

PICTURES FROM HERE SUNIL GUPTA

An Autograph book
First published 2003 by Chris Boot Ltd

Produced by Chris Boot
Design by SMITH
Editorial co-ordination by Frédérique Dolivet
Printed in Italy by EBS, Verona

© Autograph 2003
Photographs and text © Sunil Gupta 2003

Autograph – The Association of Black Photographers
74 Great Eastern St, London EC2A 3JG
Tel. 020 7729 9200 www.autograph-abp.co.uk

Chris Boot Ltd.
79 Arbuthnot Road, London SE14 5NP
Tel. 020 7639 2908 www.chrisboot.com

Published with the support of the Arts Council of England
With thanks to Helen Cadwallader

A CIP catalogue record for this book is available from the British Library.

ISBN 0-9542813-2-2

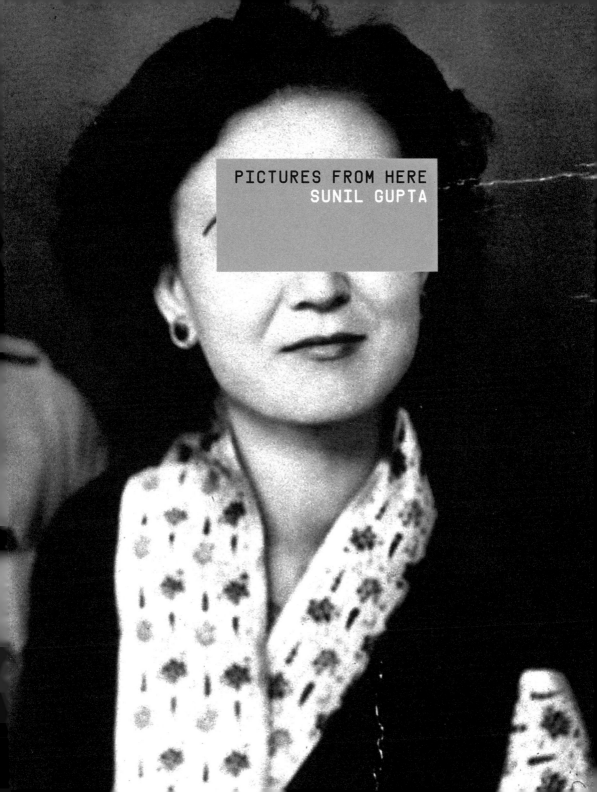

PICTURES FROM HERE
SUNIL GUPTA

Contents

Introduction

Where shall I begin this story? Perhaps here in the early years, growing up in India in the 1960s without television, watching Bollywood films where colour and narrative was everything. Or here, in the late-teen college years of art cinema in Montreal where my interest in photography began in the liberal committed way in which it was to develop. Movies certainly came before photography. I didn't see any actual photographs from the Modernist canon until the mid-1970s when by chance I was in New York just as the photo scene was exploding. Suddenly photography was everywhere and I was seeing actual prints. Yet it didn't seem contrived as it often does now, in that although there was the historical material and the recent past on view, there were also endless shows of contemporary living photographers, conveying passion. I met a buyer with whom I went around galleries and salerooms while he selected pictures - by Strand, Winogrand and Arbus - for clients in Texas and California.

New York felt like home, as it does for many expatriate Indians being the cultural and crowded mix that it is. The street became my own theatre. I enrolled in classes with Philippe Halsman, Lisette Model and George Tice at the New School, ditched an MBA programme that I was ostensibly there for, and took Lisette's advice: "Darling, I think you should do photography". She was the most inspiring teacher I ever had, I think because she held very strong views about everything. Museums she said were repositories of work when it was dead. We went on field trips to the Met to see the crowds looking at all this dead art. And yes, it did feel like a giant mausoleum. I took pictures of the living everywhere. My favourite haunts became Christopher Street, the epicentre of the Gay Liberation Movement, and mid-town Manhattan street corners where everyone from all over the globe seemed to criss-cross in an endless parade of hustling. My methods became very formal; down-rated Tri-X in a Leica with a normal lens, zone system processing and perfectly exposed contact sheets. But the pictures weren't decisive moments; they were more like film stills, the narrative not only within but between the frames.

Halsman's classes were held in his studio on Central Park West, interrupted by his wife Yvonne serving tea and biscuits. He told marvellous anecdotes about the celebrities he had photographed for Life and gave thorough, practical classes about lighting. You can photograph a lot with very little : one camera and one light source. Somehow at that moment, photography seemed a wholly democratic passion, unsullied by thoughts of getting ahead. In one short year, in an amazing setting, I learned the basics of photography, never realising how privileged life in Manhattan was. The Tice classes were about printing one negative in a dozen different ways. The prize was the archival print.

England was a shock. Art school seemed to have completely different ideas. My fellow students seemed obsessed with shooting and cameras and didn't seem to care quite as much about the print. Of course, they hardly ever saw any original prints. It was all in books or slides. Although it was tempting to quit and get to work, I needed to stay on for visa requirements. I ended up studying for five years between Farnham and the Royal College, getting and MA and fulfilling some inner cultural Indian need to acquire degrees. Graduation was a trauma. I was visibly angry with my tutors at the Royal College for having failed us. They tried to calm me down as we were hosting Kertész for lunch, but I felt I had to tell them what I thought in case I never saw them again. In retrospect, John Hedgecoe did leave me with a lasting legacy, to pursue my interests in a single minded fashion regardless of other people's opinions, and in the face of countless rejections to come, I was able to continue making my pictures. Meanwhile my visa had run out. I returned to Canada to re-apply for a permanent visa, and spent several months in limbo back at the parental home.

Finally I was able to return to London and work freelance. Not being able to work in a full time job forced me to go out and hustle picture editors for jobs. I settled into several years of jobbing in the day and cultural activism at night. I enjoyed the challenges of daily assignments and the rewards of seeing the images in print. I felt my facility for seeing and making an image was being honed

into a valuable skill. In the meantime my real, romantic reason for staying on came to an end and I made an attempt to return to Canada on a more professional basis. But my work was rejected by the Canada Council for being too British, and the local Toronto freelance world was already sewn up. Several people advised me that London would prove a more fruitful market in the end. So I returned and after one more attempt to leave, this time for California in the early 1990s, I suppose I am here to stay. I got a job teaching in Hull, and then a curating franchise. I gave up the freelance-shooting world, which had become formulaic and ceased to be challenging, and embarked on a curating career alongside making pictures, which seemed more in keeping with activism. It brought me into contact with aspects of the art world just in time, as the world of independent photography was about to collapse.

India, while it had loomed large in my freelance days, faded in the 1990s as the curating role took me to many other countries. My need to go to Canada diminished after the death of my father, but it became a place of curatorial interest; I travelled there regularly and still do. I still feel a coherent place in the discourse of Canadian cultural politics, something that is difficult here in England. I feel I am here, in London, because it's an international hub but England remains foreign. I am an outsider. In the 1990s I made an extended series of pictures about being a foreigner. Now with a chronic illness, I feel the likelihood of physically relocating is remote. I am here to stay. On the other hand, my interest in India and its history has been revived and refuelled by recent visits and projects. So if here is in one's head then mine is in Delhi, as a kind of romantic ideal, with part of me in the familial safe haven of Canada. My body has rooted in South London.

Tilonia

Tilonia is a village in Rajasthan, India. I came here for the first time in 1980 to practice a form of liberal photojournalism but was transformed by what was my first encounter with institutionalised rural poverty. The visit was the consequence of a student travel award. I had been a family friend of one of the people running an NGO based in this village and, having heard about the interesting work being done there, I chose to go.

It was my first return visit to India since leaving it as a teenager and an awkward moment; the intervening years had been spent without any reference to my earlier life in Delhi and now I had to bridge a gap in both directions. Whilst enduring a period of quite physically demanding assimilation, I was still trying to figure out how to go about communicating what I was doing with a camera. Here suddenly I had to reconstruct my Indian self. Coming from the West was going to be a barrier if I couldn't demonstrate that underneath, I remained as Indian as the rest of them.

In the first few months I found it impossible to shoot. I felt I was looking at the symptoms but not the causes of under-development. It became a challenge - what to show, what not to show. It was too easy to show the death and deprivation resulting from years of feudalism and neglect. Back in England, we had been questioning the contradictions of photojournalism and image making of this kind. I was struggling with the near impossibility of visualising the complex relationships that lay beneath the surface of appearances. Both the place and its inhabitants were also attractively photogenic and I was aware that just on the other side of what I was doing lay the pitfalls of tourism and ethnographic photography.

In the end I formulated a strategy. I would abandon the idea of a conventional storyline. The chain of events that led to the problems of the village happened very gradually, over generations, and I could not reflect these in a short visit. I decided to make a portrait of the place and organise the story around broad political issues -

education, land, women, access to water - and rather than let the images fall into generic types, to try and make pictures of particular people.

I was able to return several times on much shorter visits that enabled me to maintain my relationships there, and to show the photographs I had made. I needed to convince my hosts, and myself, that I was here for more than professional reasons. I tried to explain my position; that I was caught up in a job that was used to treating them as objects; that I was trying to break the mould and empower them in some way even though they had no way of experiencing the end result - pictures of them distributed on the editorial photography market and shown on a wall in London.

When I finally exhibited the work, despite all my labours to guide the audience's experience of the show, the colonial baggage they brought to it pretty much overwhelmed the work. To a certain extent, the use of seductive colour imagery did draw people into the story, but shifting the focus into the subjective and the particular wasn't working. I began to feel that the kind of constructed, subjective reportage that I wanted to do just wasn't going to work with the available means of showing and distributing it. Magazines said that the story was too soft. I wrote my RCA thesis on how the Western media is obsessed with showing pictures of dead people from other places, either through war, disease or starvation.

Subsequently the pictures went into circulation as single images via the charities that supported the trips and a couple of agencies. I resolved not to make more pictures of India for the editorial market. My resolve found reinforcement from some sympathetic comments made by a picture editor in New York, who liked the pictures but said we were all heading for glossy images of minor celebrities for our magazines. That was more or less the direction my working life took in London in the 1980s.

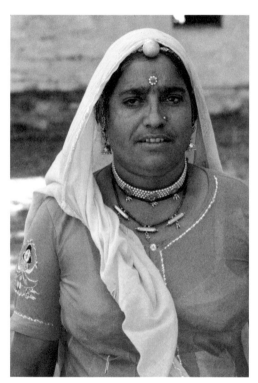

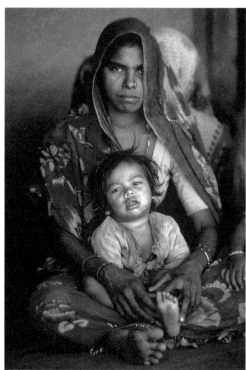

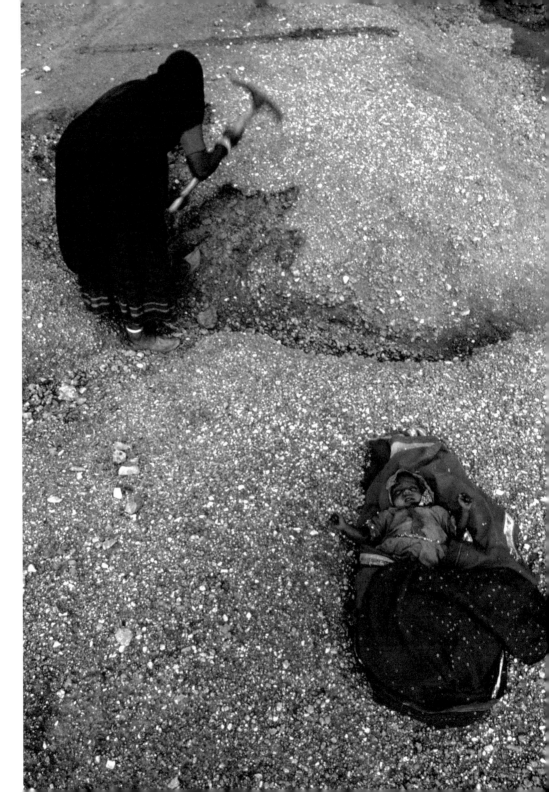

WOMEN FETCHING WATER
CAMEL FAIR, PUSHKAR

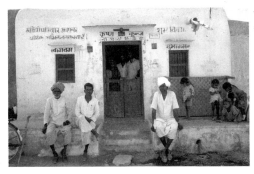
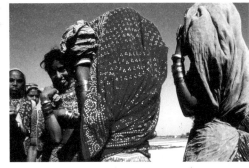
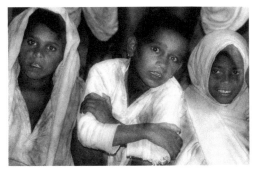
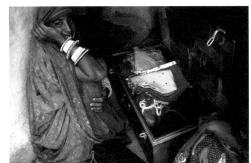
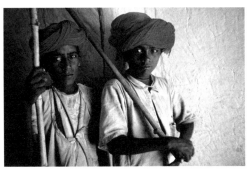
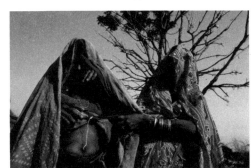
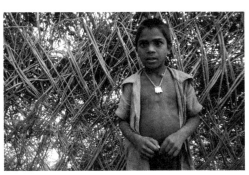
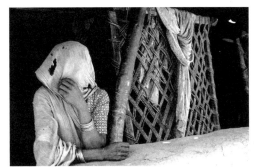

TILONIA

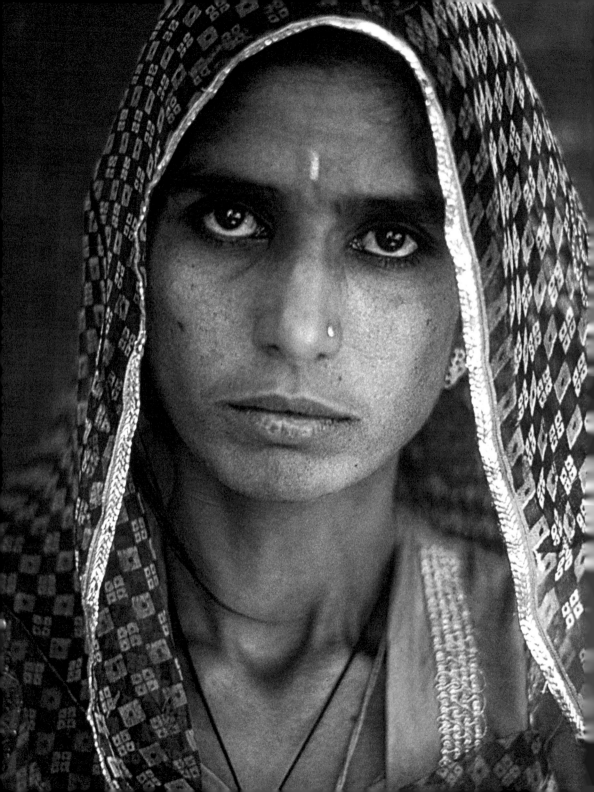

RAJPUT [CASTE]

>HARIJAN [UNTOUCHABLES]

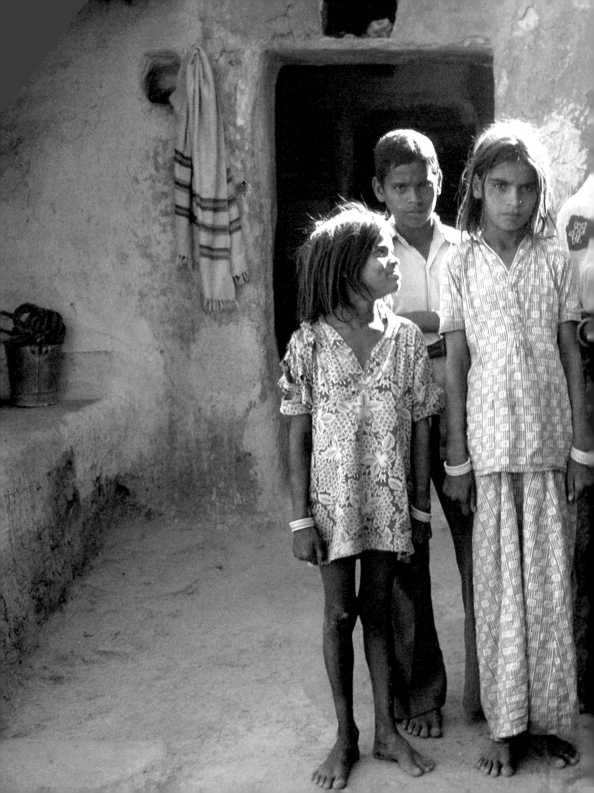

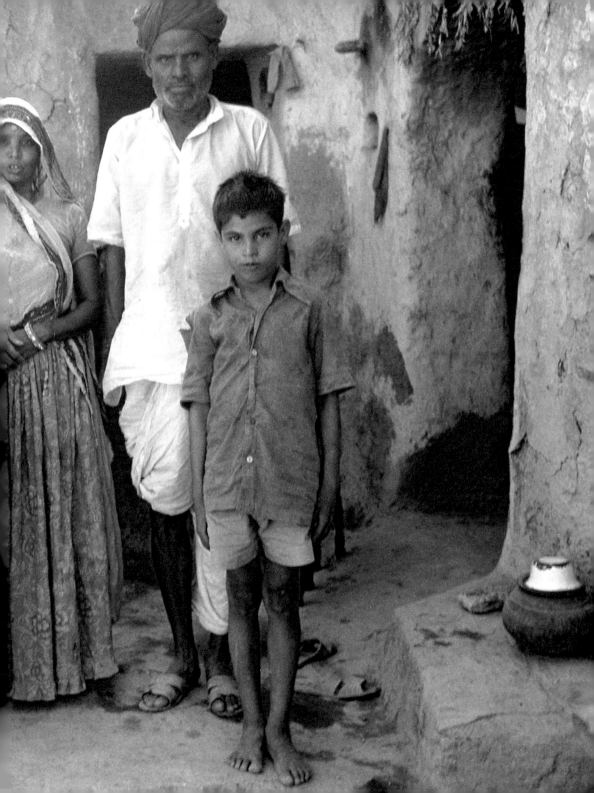

Ten Years On

Around 1984 my first relationship ended after ten years. It came as a surprise as a number of major life decisions had been made because of it, including being in England and going to art school. I thought I had broken with the stereotypical instability of gay life. My father, in our one and only discussion about homosexuality, included in his litany of arguments against it that it was going to be a lonely road, that these relationships don't last.

I set out to find gay male couples around me to photograph as a means by which to meet and talk to them and maybe unravel the secret of their success. Of course, there was no such secret to unravel and looking back on the couples that I still know from then, half are still together and half are not. Why they are together remains a mystery. I went straight on to another ten year relationship, then another shorter one. Now I am learning something I never learnt in my youth: to live alone.

The project wasn't conceived as some sociological survey so the people reflect the kind of people I came into contact with at the time. A number of the couples were living locally. I wanted the pictures to be empowering so I used a normal lens and black and white film, and had the subjects of the portraits look straight back at the viewer. Unafraid. I wanted to minimise distortion so that we could see who they were, or at least what they looked like.

I have always felt badly served by the generally accepted notions of the history of photography. It never reflected my own life experiences, but rather a white, heterosexual liberal viewpoint; subject-matter that was different always seemed to be treated in some particularly skewed way. Gay men, if depicted, were treated as perverted objects, fixated with the penis, and presented for a fetishised gaze. One looked without much success for photographs that depicted something of a gay man's humanity and the everyday relationships that define him.

20

KARL & DANIEL
PABLO & CHARLIE
SUE & YVE
DAVID & PETER
MARTIN & GARY
LISA & EMILY
TENNEBRIS & ROY
BOB & TIM
KEITH & IAN
BRUNO & DAVID
GUY & BRIAN
SIMON & IAN
EMMANUEL & DAVID
DYLAN & GERALD
STEVE & STEVE
JOHN & JOHN
EDUARDO & EWAN
PAS & BRIAN
ADDI & NICK
ANDREW & JOHN
PETER & KEITH
EDDIE & JEFF
CHUCK & DAVE
GEORGE & STEVE
IAN & JULIAN
SIMON & JOHN PAUL

 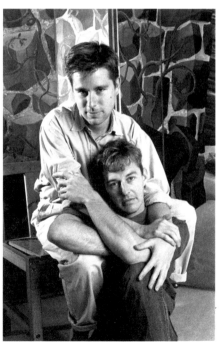

TEN YEARS ON

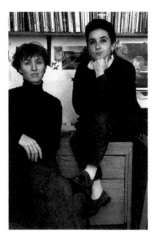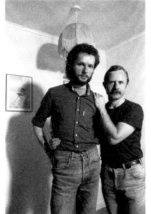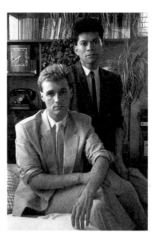
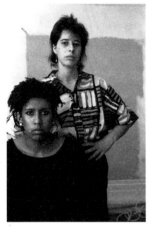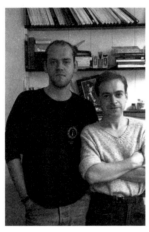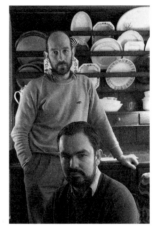
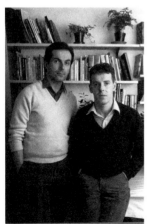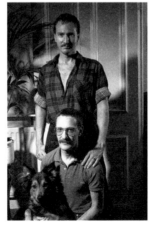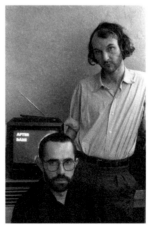

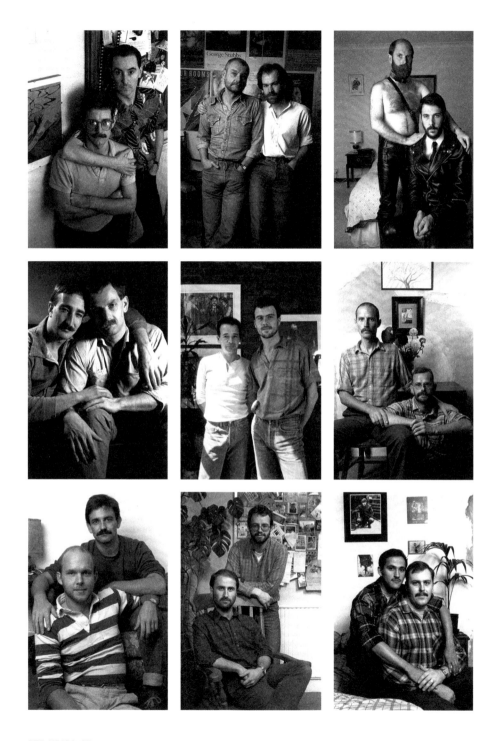

Social Security

My parents set themselves up as a middle class, urban, nuclear family in post-Independence India. By the end of the 1960s they had left for Canada where it was hoped the family would flourish under a more conducive economic regime. The outcome was unpredictable. Exposed to the curious gaze of the host culture, the family withdrew into itself. We the children began a process of disengagement. Huge tensions built up which led to our further distancing ourselves, initially away from the parental home and eventually to other countries.

By now a Canadian citizen living in London, I was asked by Canada House to participate in a set of three solo shows in the East End of London. I decided to make a work about my family's migration to Canada and its consequences.

In India we were surrounded by relatives, friends and people. In Canada however we withdrew into a solitary family unit spending inordinate amounts of time together. This was new for us. Living in the Downtown area of Montreal at a time when there wasn't a large group of fellow Indians, we were left to our own devices. We lost social standing by making the move and my parents no longer had access to people in any position of power. Given their age, by then approaching 50, it wasn't a good moment to forge a new life and a new career. Money became an enormous problem. So, while the move spelled some sort of potential for the children who were young enough to retrain and assimilate, for the parents it was a disaster. They never recovered their social standing, and they presided over the unforeseen break-up of the family.

A greater sense of social security is what they came for, but actually ended up very insecure in a province which by then was about to be split on its own nationalist issue of separation from the rest of Canada. At times we lived on the edge, dependent on handouts from the official Social Security. The sense of our family's journey is encapsulated in images drawn from the family

album and fragments of text edited from recorded conversations and letters my mother wrote to me in England. I had the photos blown up large.

I dedicated this work to the memory of my father who died on a street in Montreal in August 1986. It took the authorities three days to locate his body in the city morgue, I presumed because the colour of the skin he wore labelled him simply immigrant. When we eventually recovered the personal possessions from his body, we found that his Social Security card had been neatly cut in half.

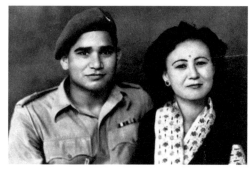

Ram & I, we were friends. I met him when he was in the army. At that time I was working in the telephone exchange in Delhi. It was a love marriage.

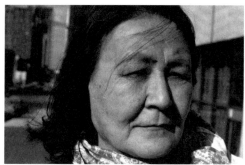

I had ambition to travel. After the war I settled down with my husband. I wanted my kids to study abroad. We met a Canadian who encouraged us to apply for immigration.

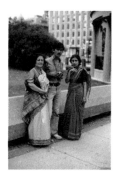

Ram went in 1967 in April when they had EXPO. We landed in Montreal, because the person who had sponsored us lived there and he looked after Ram.

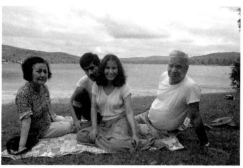

Remember, Shalini never wanted to come to Canada, but she was fed up of Air India, and in the end she preferred to come home.

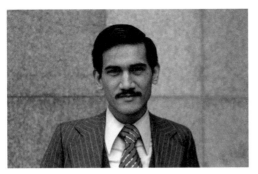

Those were exciting times. Shalini got a job at McGill and did evening studies. I was working as a substitute teacher for the Protestant School Board and you were studying to be an accountant.

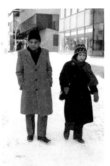

Daddy and I enjoyed going about and sitting in the parks and visiting the Botanical garden. The weather in Montreal is wonderful.

Daddy believed that Rudi took you away from Canada and was angry about that for years. You promised us that you would come back after the Royal College, but you still haven't.

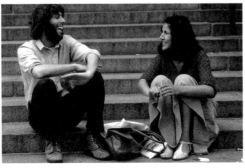

Shalini met Larry at Johns Hopkins and very quietly they got married. He wasn't the kind of boy we had hoped she would marry. He kept studying for so long, he wasn't Indian and they lived in such far away places.

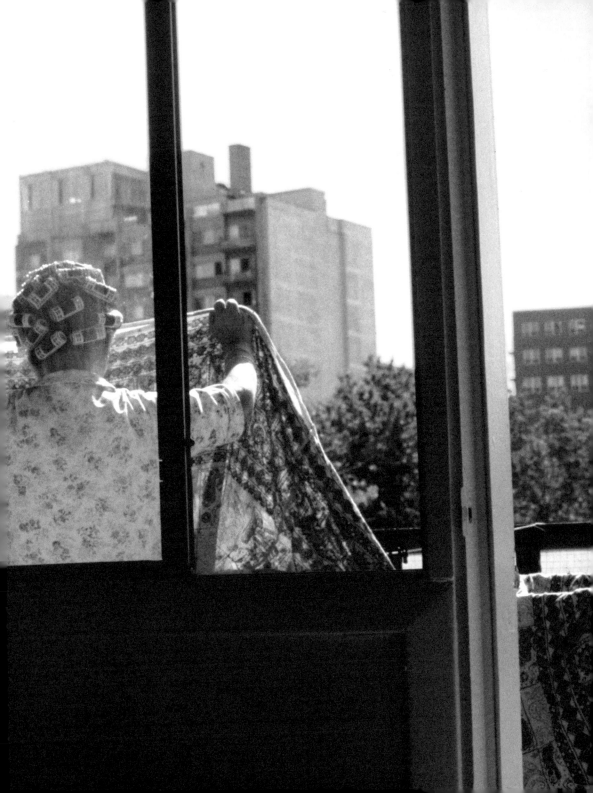

Daddy had problems finding a job and eventually worked as a commissionaire. For several years he worked at night at the club on Sherbrooke Street. It was very bad for his health.

Montreal is a beautiful city, you should come back to live there. Why are you sticking on to London? I brought you to the West not to live in the ghetto!

Daddy and Shalini's relationship was very stormy. They loved each other a lot and fought a lot too.

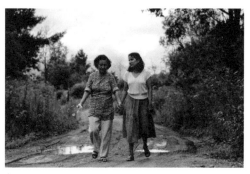

We are like sisters, we discuss things together, our ideas are not hidden from one another.

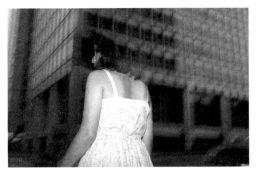

Shalini likes to boss me, but I am her mother and I know everything about her so I can get the better of her.

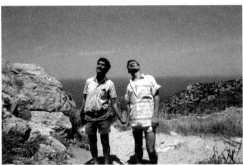

Then you brought Steve to Montreal, against our will, when will you settle down? Next time I go to India I must find you a wife.

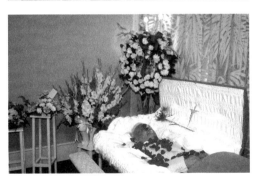

Daddy became very angry in Canada because he didn't achieve all the things he set out to achieve. He felt you two had left us and didn't care about him. When he died it was a great shock to me.

It was very exciting when you two came back for Christmas, although daddy would have preferred that you came alone. He always wanted all his kids to live with him.

Reflections of the Black Experience

Inviting the Greater London Council's Race Equality Unit to attend the first student-led black group show held at the Royal College of Art during our graduation year, 1983, brought me into contact with organised Town Hall politics. I met Ken Livingstone who chaired some interesting meetings with advertising agencies supposedly promoting a multicultural London. I began spending time on London's Anti-Racist Arts Sub-committee. This led to meeting individuals like David A. Bailey and Monika Baker who were formulating and carving out an area for Black practitioners, efforts that eventually led to the formation of Autograph - the Association of Black Photographers.

A number of related public events were organised under the heading of The Black Experience. Commissioned among 10 photographers to contribute 10 photographs each to an exhibition, I decided to make mine about aspects of British Asian life. Only two of the ten photographers were Asian and at that point in time, issue-based photography was firmly set in one's own sub-culture. I faked a series of reportage scenes around a range of immigrant issues. By now the pictures were wholly subjective. Occasionally I would try to introduce this subjectivity into my freelance editorial photography but editors would always recoil with horror. I was amazed at the extent to which the media still thought it was dealing in objective truths, well into the Thatcher years.

Politically, this has been the most important project that I have ever participated in. It brought me into contact with grassroots politics and the inner workings of local political power, and it gave me a sense of the body politic in which my personal interests in photography could play a part. It was a far cry from the elitist world of the Royal College and South Kensington. Identities shifted away from our being merely artists to being activists. Other skills became equally important: writing, organising, formulating strategic plans.

The project brought photographers out of the woodwork and together for the first time and under the umbrella of the GLC, meetings began to take place as more practitioners were sought. It brought me into personal contact with David Lewis, Ingrid Pollard, Armet Francis and others who I might never have met otherwise. After two interminable years of meetings a core group remained who sought funding from the Arts Council. A small research grant led to the formation of Autograph, an internationally unique agency that bridges Asian, African and Caribbean cultures and marries them to photography. Monika Baker and I job shared the running of Autograph in its early years in Brixton - a melodramatic experience whose emotionally charged meetings remain unforgettable. Here we faced a group of disenfranchised artists and photographers who expected you to provide for them all the things the 'system' had failed to: access to education, training and jobs. For me, it was a very exciting political moment.

ELDERLY

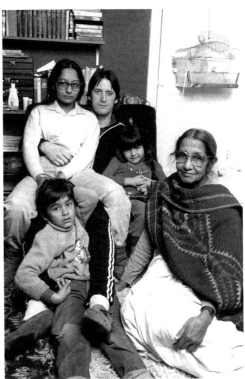

Exiles

During the 1980s a vexing question surfaced: why wasn't I living in India? As a gay man living in the West I was in danger of losing my Indian identity. A student of the 1970s, I had embraced the gay liberation movement without question and the issue of ethnicity seemed irrelevant. The experience of art school and 1980s London brought race to the fore. There didn't seem to be too many other gay Indians around, not on the gay scene, nor amongst activists and certainly not on the art history circuit. Surely I couldn't be the first? But I knew from having lived in India as a child and having returned there that there was homosexual activity. It just seemed to lack cultural expression. In my comings and goings to make pictures in India I had explored this informally, and later with the serious purpose of helping contribute to a cultural history.

Exploring the Indian gay scene as an adult I found an intimidating wall of silence. The handful of gay men of Indian and Pakistani origin I had met in the West felt unable to return to live in their countries due to family pressures of marriage. Those I met in India lived a marginalised existence, giving in to communal pressures to maintain a 'normal' front. A few at the top and bottom of the social and political ladder were privileged enough to side step these pressures. Very few who identified with the secret 'dirty habit', even those who labelled themselves gay, felt able to come out from this self-imposed internal exile. News of gains made by gay activists in the West to foster a positive gay identity and culture filtered in, but their tactics could not be exactly duplicated in India. On the other hand, HIV/AIDS arrived to reinforce all the worst stereotypes, the most common of which was that homosexuality is some terrible Western disease.

Much as I felt committed to India, after a few months (even without the pressures of my immediate family) I began to feel claustrophobic and had an intense desire to get out. I can remember feelings of immense relief, leaning against the wall of a gay London night club on returning from India, that this gay sub culture was home, even

though no-one there knew me. I felt more intimately connected. I decided consciously that I couldn't return to live in India if there wasn't a space for me to be myself.

When the Photographers' Gallery wanted to commission a body of work, I jumped on the opportunity to finally visualise this issue of invisible gay Indian men. I called it Exiles. It seemed wherever we lived, we were cut off from India and there was an overwhelming, deeply frustrated desire to claim some part of it for ourselves.

I didn't want to make lurid sexual imagery, as sex didn't seem to be the problem - it's widely available in India - but focus more on larger cultural issues of living there. I also didn't want to spy on unsuspecting men so I found a small cast of willing gay accomplices who would enact the rituals in real spaces. I was honing my skill at creating subjective reality in a real place. The sense of place was very important, and Delhi as both my hometown and India's capital seemed an ideal location.

I was very pleased with the resulting show but the work was not remarked upon, perhaps viewed as an ethnic aside in the context of a group show about the body. Looking back, it might have been ahead of its time. Reviewers were still struggling with Black artists' work. Strangely, one of the pictures has reappeared in an exhibition at the Tate Britain but in a room full of Black artists, not in the adjacent room about the body. For me, the sexual identity of the subjects was just as significant as their colour. British art institutions have some way to go yet in their categorisations of people's work.

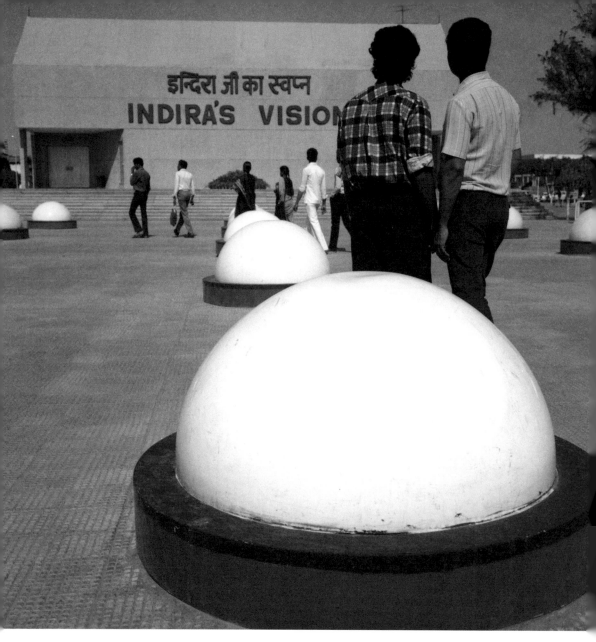

INDIRA'S VISION

Why do you go on about changing the law? I don't want to be a martyr. I'm happy the way things are.

JANGPURA

I am tired of being alone with no prospect of meeting anyone I like. I'm nauseated by the party and park scene.

EXILES

CONNAUGHT PLACE
**This operates like a pick-up
joint. People don't want to talk,
they just want to get it off.**

It must be marvellous for you in the West with your bars, clubs, gay liberation and all that.

EXILES

HUMAYUN'S TOMB

**Americans, talking about AIDS
and distributing condoms.
Nobody believes them. They're
always telling us what to do.**

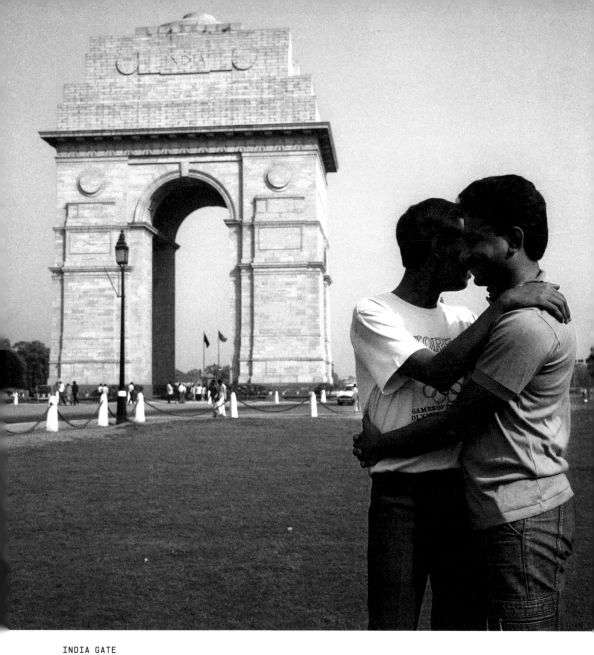

INDIA GATE

Even if you have a lover you should get married and have children. Who would look after you in old age?

EXILES

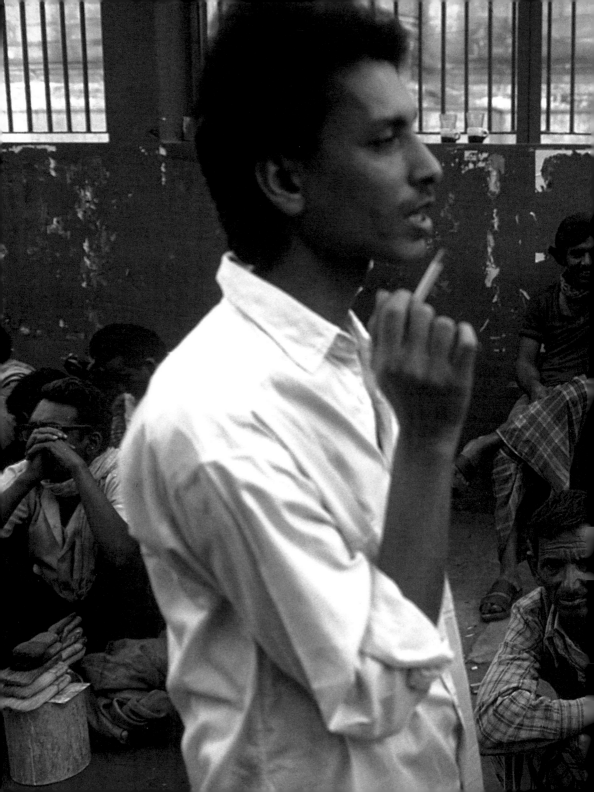

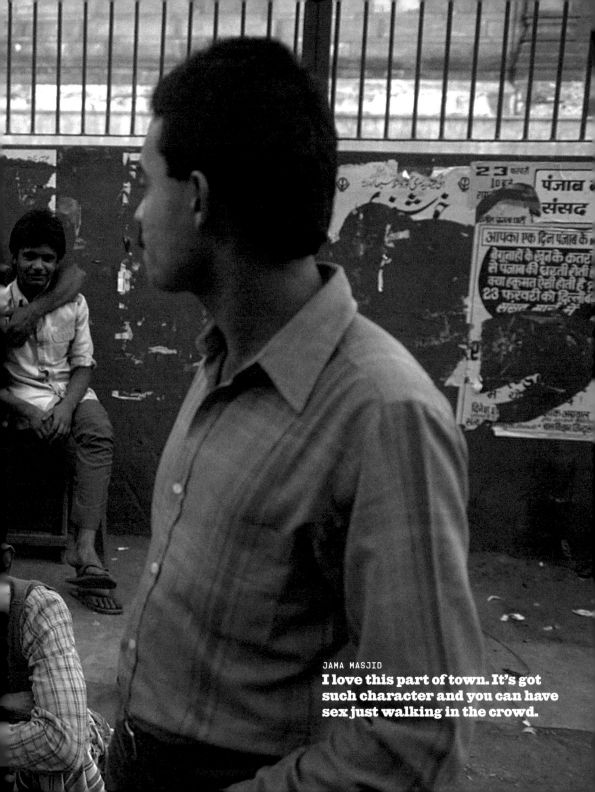

JAMA MASJID

I love this part of town. It's got
such character and you can have
sex just walking in the crowd.

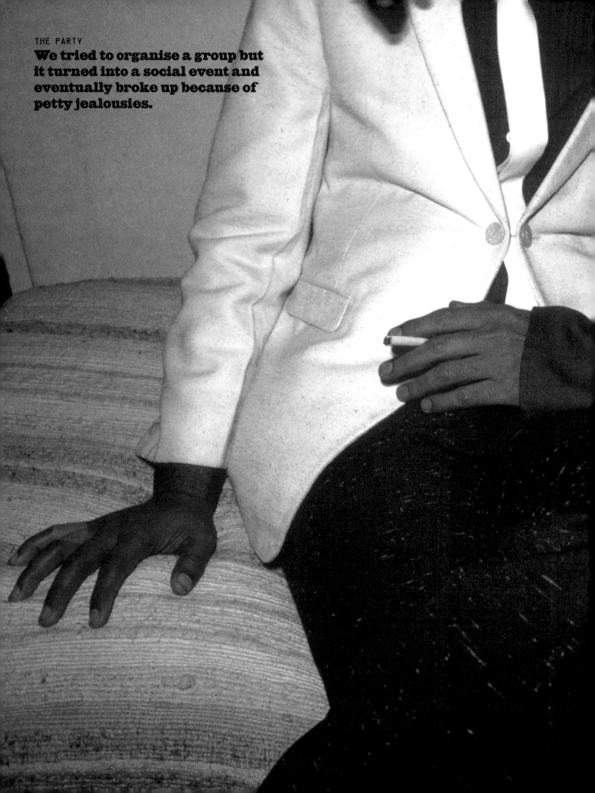

We tried to organise a group but it turned into a social event and eventually broke up because of petty jealousies.

We're sharing this flat with a woman. The neighbours have learnt to live with us. We like our freedom.

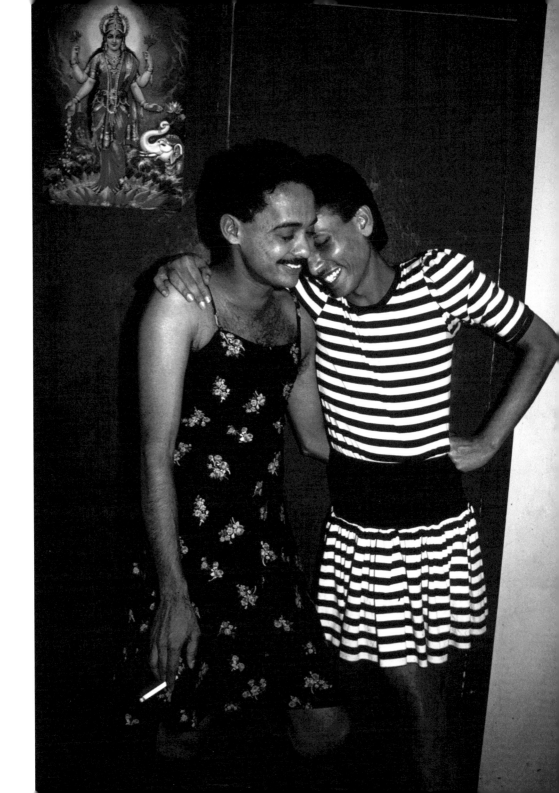

'Pretended' Family Relationships

In the late 1980s a very interesting idea emerged in a roundabout way that lesbian and gay relationships were not real, or not as real as heterosexual relationships.

'Pretended' Family Relationships began as a series of colour photographs and poetry, exploring the ambivalence surrounding multi-racial gay male relationships. I was in one and it seemed to be quite the cool thing to do in London. Meanwhile, Thatcher's government introduced a clause in a Local Government Bill, which became law on 26 May 1988, banning the 'promotion' and teaching of the acceptability of homosexuality as a 'pretended family relationship'. Inevitably the original idea of the series became extended to consider the impact of 'Clause 28'. I decided to address lesbian relationships for the first time in my work, and sections of black and white photographs of demonstrations against the Clause referred both to the necessity of political action and to the problematic nature of such documentary evidence. It wasn't essential for the couples portrayed to be really together - some were and some weren't. And it was difficult to find subjects of colour willing to be portrayed under a lesbian and gay banner.

In those pre-digital days, I made the montages by hand and installed the shows by assembling the parts on the spot. As an in-joke I made the overall proportion of each piece the same as a 35mm frame. Although I did not get favourable responses in England, the work was seen in the USA and Australia, and it took me to a seminal panel discussion at a Society for Photographic Education conference in Houston in 1988. I felt I had found a hospitable environment for the lesbian and gay work in contrast to the cold shoulder I was receiving in England. Here I met people who were working on very similar issues, with whom I was to have ongoing long distance discussions: Deborah Bright, Doug Ischar, Kaucyila Brooke, Douglas Crimp and Hinda Schuman.

In England there didn't seem to be the density of practice, and very little curatorial interest in these issues. Shortly after, I did meet someone in London who shared these passions - Tessa Boffin - and we forged a close working relationship. We once went to meet a curator at the South Bank whose opening remark was that she was put off by our black leather dress code. As in the Black Arts arena, we found ways to organise our own shows. Clause 28 remains on the British statute books.

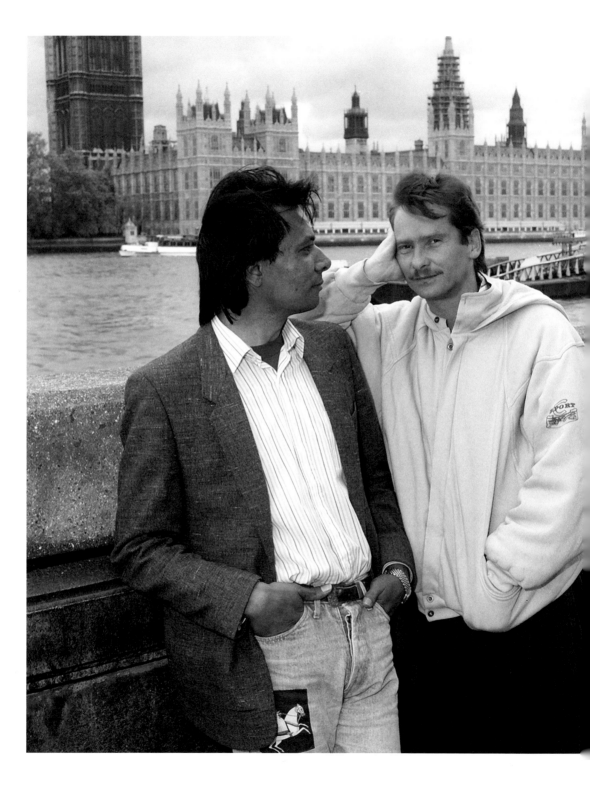

I call you
my love though
you are not my
love and it

breaks my
heart to tell you

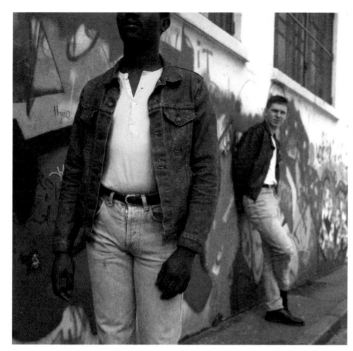

At night, in
this dark and neon-
flaring street, cars
splash puddles
of fragrant
diesel, caught
in a headlamp flow,
and the memory
of a moment's

pause (shaped
like a curving
leg) is fanned by
a hungry upward
turning, half-
transparent blaze
of flaming red

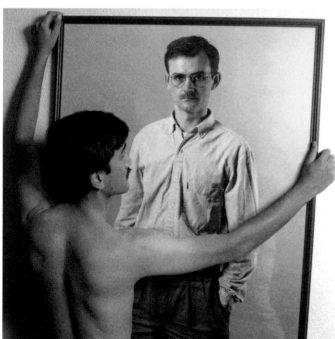

He needed
dope
to get it

up but once
it was
there he was

hooked
on it

Seeing you, seeing me, it all becomes

so clear

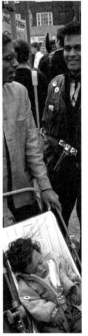

Round white tower set in evening blue of sky, seen through a clearly washed and perfect window-pane, sometimes

we are as clear as that

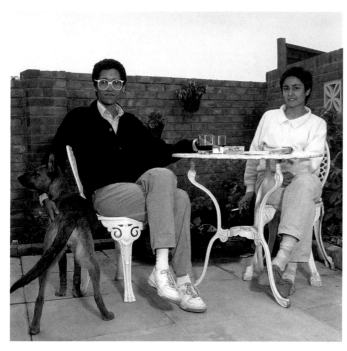

Lighting
a cigarette

You're not here

Lighting
a cigarette

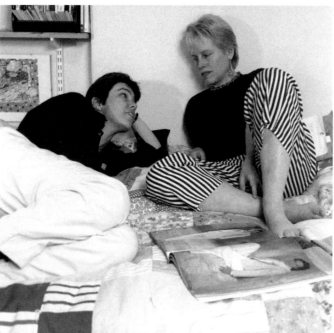

Repeated,
these night time
confessions
over tea
a train

rumbles through
on the pause
of our thought

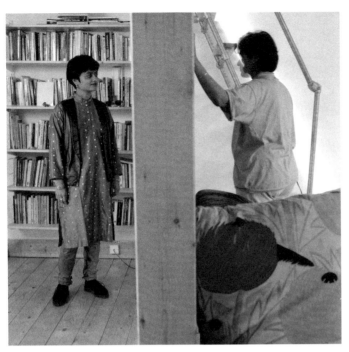

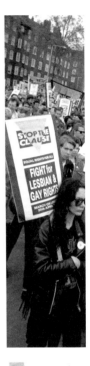

What you
got tell
me the l
ines of
your pre

tty blac
k hair

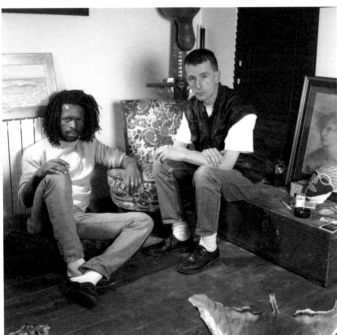

If anger
is a sign of love,
our signs have

locked like scorpions

'PRETENDED' FAMILY RELATIONSHIPS

Round moon; disk
light thinner
than city winter

lamps through
which we drive

Trespass

Trespass was conceived as an open ended long term project that I could work on in parts. There were a number of different approaches that I wanted to use to explore the notion of being a stranger in a strange land.

1992 was an interesting year. I was awarded a substantial sum of money to start up a curatorial agency which freed me from both commercial work and teaching. It was also the 500th anniversary of Columbus's voyage to the Americas. I found myself in the art world both curating and being commissioned to make my own work for an art project called Trophies of Empire which was to be a counterpoint to the celebrations marking the anniversary of the Columbus voyage.

A great debate was raging about Britain's membership of the European Community at the time and it seemed obvious that the colonial legacy of Columbus was us migrants. The question was: where would we stand in a new united fortress Europe? My own presence here is governed by a very tenuous-looking stamp in my passport which confers a 'right to remain indefinitely'. But how long would that last in the changing circumstances? Furthermore the whole notion of becoming British, or for that matter European, never seemed likely. It seemed as immigrants, we would forever trespass on this newly defined terrain. 'Ethnic cleansing' and other such terminology was becoming commonplace in the press. Looking at a map and the newspaper headlines of the day, it seemed that Germany would be the new centre of Europe and so I set off for Berlin to make pictures.

Although I wasn't sure what I would find, I found Berlin highly stimulating. Perhaps I was simply one of those photographers inspired by being away from home with time and freedom to shoot what I wanted. In the spirit of experimentation, and as this project was 'art' rather than 'photography', I treated the camera as a recording tool. I was collecting images that I could manipulate

once back home. It was enormously liberating to follow one's instincts and not be bound by the frame or format.

I used very simple technology to present eight mural size images ariculating concerns about the notion of the New Europe, in spite of the concrete realities of migrant cultures and the hegemony of Eurocentric cultural traditions. Making enprints, I scanned them on a very early flatbed scanner, made digital montages and had them blown up on paper. I wasn't at all concerned that the image would break up in an unpredictable way, or that the colour balance would probably shift with each print run. It was all part of my first digital experiment. The photographs from the camera became a tool rather than an end result. I began to see source imagery everywhere and viewed my own archive of negatives with new interest as a source of fresh material. I enjoyed playing with the possibilities on the computer, while trying to remain within the boundaries of photography. I didn't mind that the images were technologically crude but equally I didn't want them to have an obviously manipulated look.

The work travelled to several galleries internationally and took me to the Havana Biennale in 1995. In the context of a global art event, Western Europe shrank considerably from it's normal size.

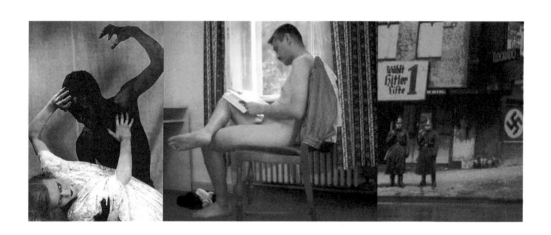

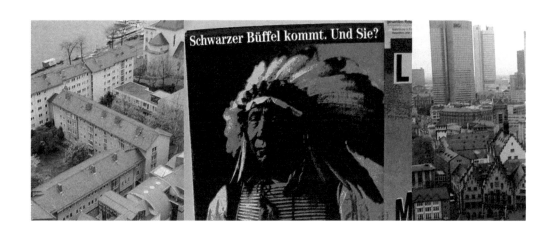

Refugees die in fire

A Sri Lankan family of three died in a fire yesterday at a home for refugees in Germany, where neo-Nazi attacks on foreigners have worsened in the past year. Police did not know the cause of the blaze that wrecked the two-storey building in Lampertheim, 40 miles south of Frankfurt. — Reuter.

The Essential FRANKFURT SCHOOL Reader

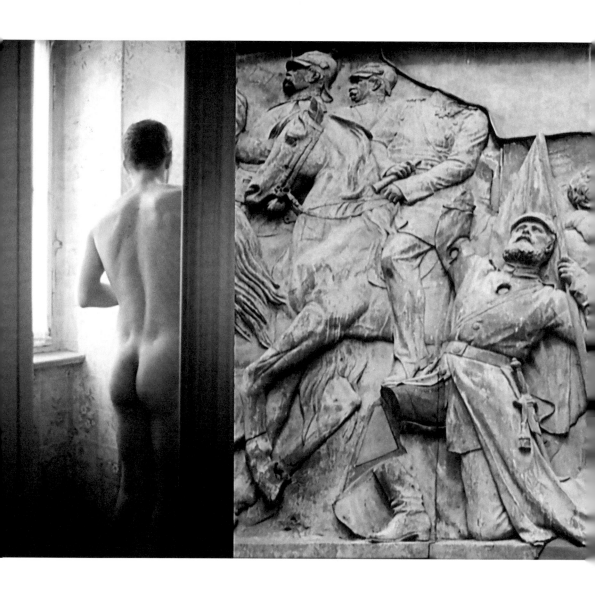

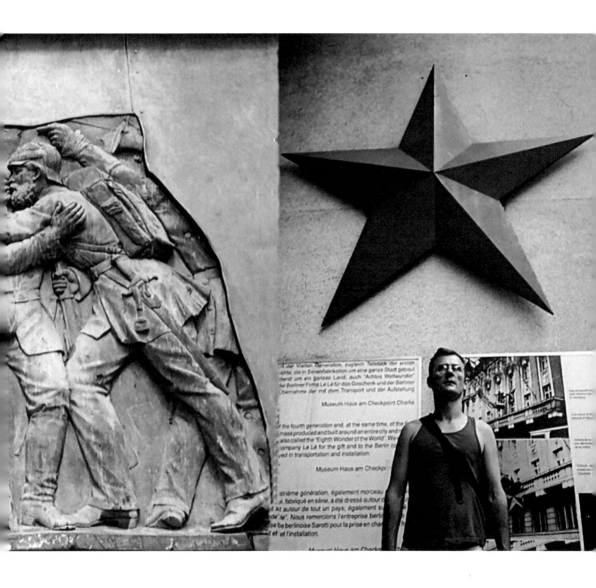

der Vierten Generation, zugleich Teilstück der ersten
...chte, die in Serienfabrikation um eine ganze Stadt gebaut
...hend um ein ganzes Land; auch "Achtes Weltwunder"
...er Berliner Firma Le Lé für das Geschenk und der Berliner
...Übernahme der mit dem Transport und der Aufstellung

Museum Haus am Checkpoint Charlie

...f the fourth generation and, at the same time, of the f...
...mass produced and built around an entire city and...
...also called the "Eighth Wonder of the World". We...
...ompany Le Lé for the gift and to the Berlin co...
...red in transportation and installation.

Museum Haus am Checkp...

...xtrième génération, également morceau...
...i, fabriqué en série, a été dressé autour d...
...il at autour de tout un pays; également su...
...de' le". Nous remercions l'entreprise berlin...
...se be berlinoise Sarotti pour la prise en charg...
...f et et l'installation.

Museum Haus am Check...

I wanted to consider the personal in the second part of Trespass. Another exhibition opportunity had arisen - a request to participate in a show in Berlin called They Call it Love, which I thought a marvellous idea. There seemed to be so few exhibitions about love. My own life had taken a rather complex turn at this point, and I found myself in a long term relationship with one man and now also with a second. Our kitchen became the site of struggle between lovers, as well as cultural identities. It had been rebuilt by one man for the use of another. It was the site of the preparation of food, discussion and sex. I wanted to reflect these combinations, and digital montage seemed the perfect means.

While I enjoyed making the work and displaying it in Berlin in what was a conceptual art show, the emotional pressure of the situation caused it to implode. I emerged with no relationships at all. My system had failed me at a personal level. This wasn't supposed to happen. It was the end of cool. I no longer felt at the forefront of forging new kinds of relationships but felt thrust emotionally back in time. With hindsight I hadn't noticed my work was beginning to replace people as the central focus of my life.

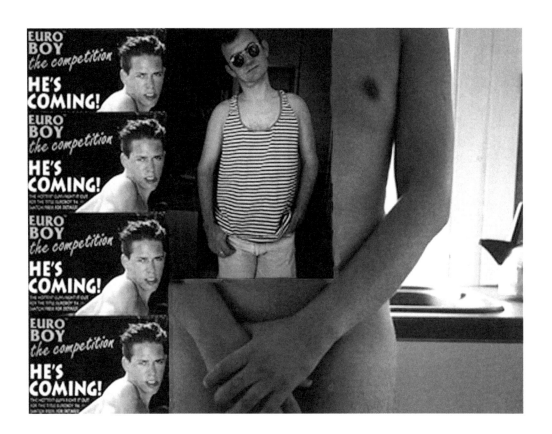

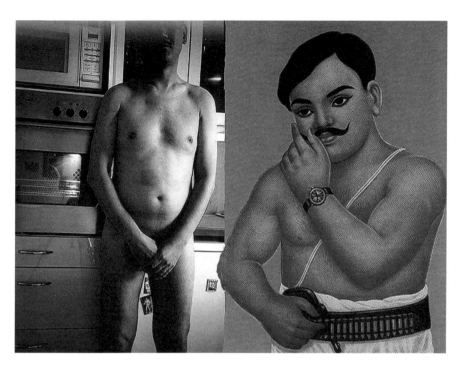

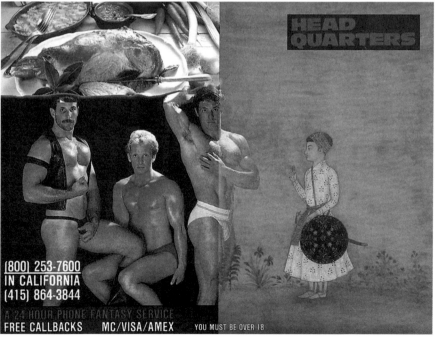

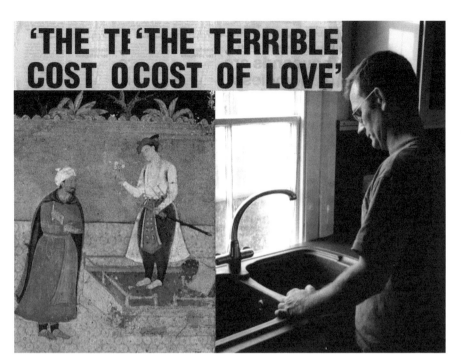

'THE TE 'THE TERRIBLE COST O COST OF LOVE'

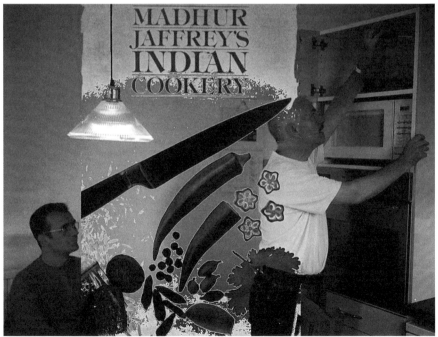

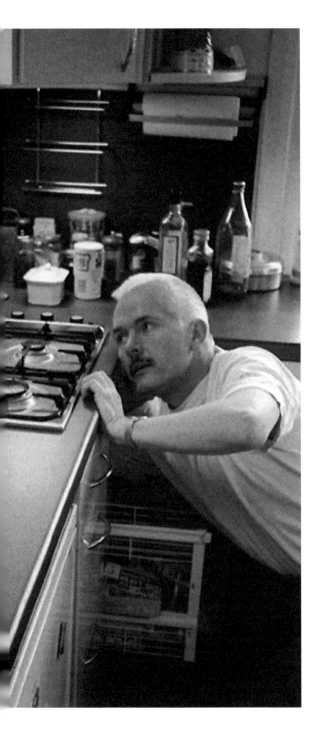

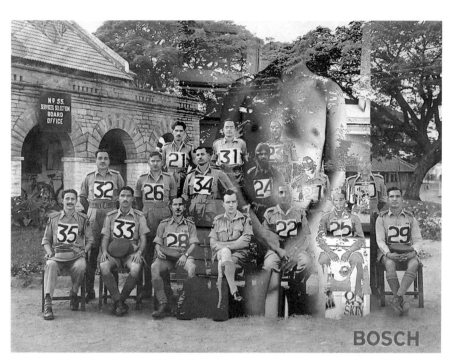

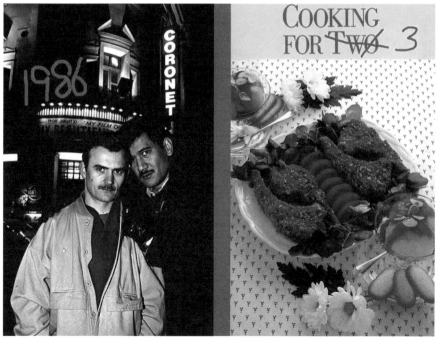

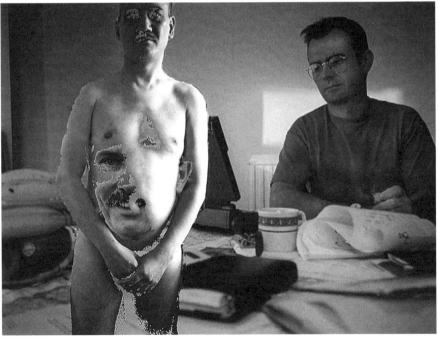

For the third part of Trespass, I was back outside. The work was focused on England in a social and historical sense. Essex was viewed as an entry point into the United Kingdom - literally where foreigners try to get in and society categorises them into desirable and undesirable aliens. There are references to the military industrial complex that underpins the power of the nation state and the seemingly puny cultural infiltration successfully made by Asians.

By now I was completely relying on the computer montage effect and using my own archive for additional material. I had photographed in the county a lot in an earlier life, freelancing for The Field magazine.

In the middle of the year 1995, I made a personal discovery that was to change my life completely. I was HIV positive. I made a self portrait that day and inserted it in the montages. Fortunately I was asymptomatic and was able to carry on as normal. For a while though, I did walk around with the idea that I was going to die soon. Of course I didn't, but it triggered a reversal of fortune and in the course of a year I lost my home, my health and a great chunk of my income. The Trespass work also came to a conclusion. I stopped making pictures for a while.

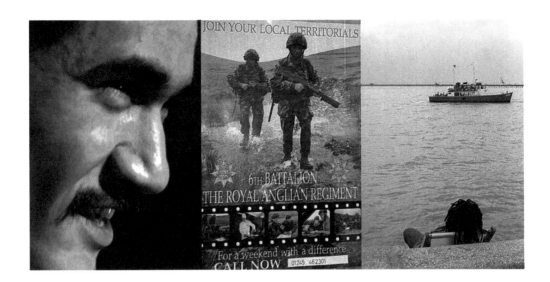

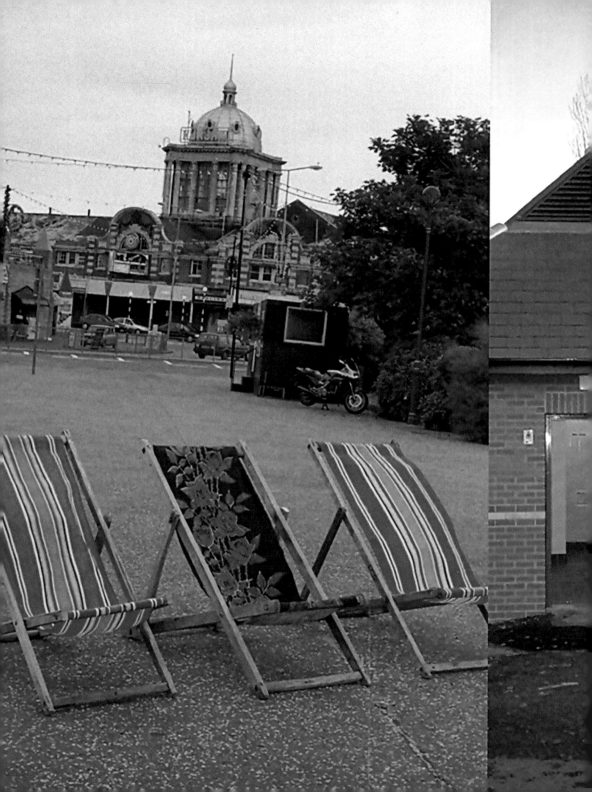

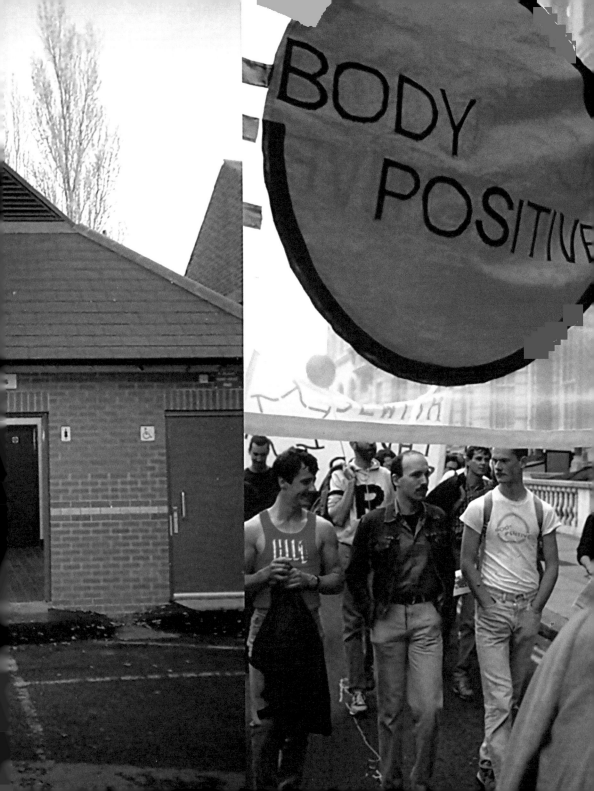

THREE MEN

MURDERED

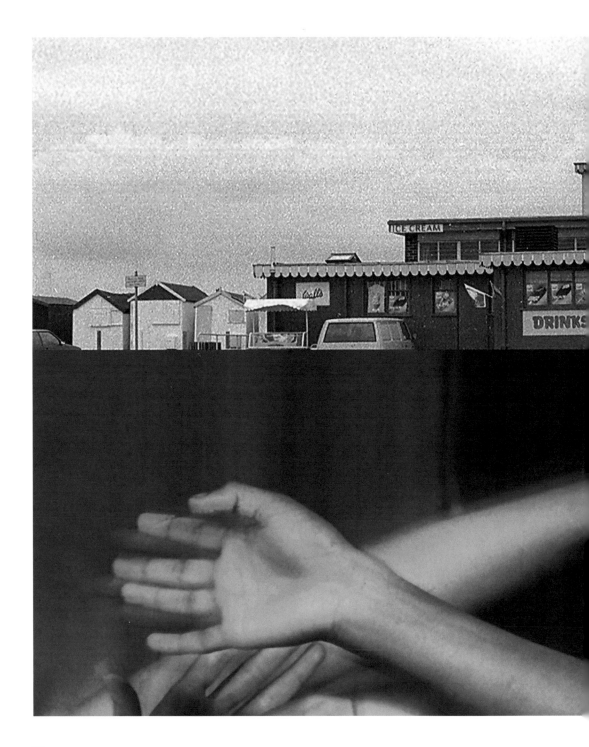

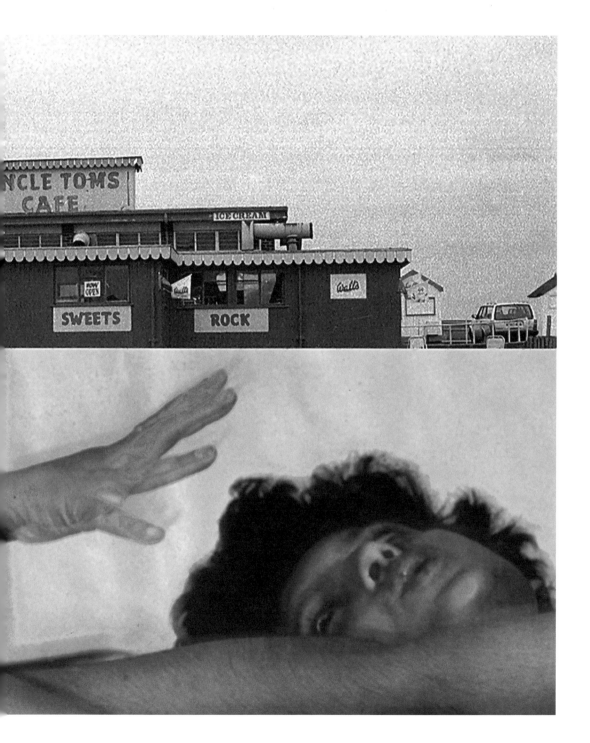

From Here to Eternity

When I was diagnosed HIV positive in 1995, the first consultant I
saw encouraged me not to focus my energies on the virus. At first
I was asymptomatic so it was easy to make a decision to relegate
the illness to the back of my mind. I had worked with HIV as subject
matter for an earlier curatorial project Ecstatic Antibodies, and
I knew that it had the power to completely take over one's life.
There were no combination therapies to deal with and I certainly
didn't want to focus my creative energies on being ill. I didn't seek a
support network that included other positive gay men. This decision
set me on a path towards social isolation from my peers once I did
become ill.

One day, Autograph rang up asking would I like to make a new body
of work for a show? It mobilised me into thinking about work again.
I had fallen into a slump, completely absorbed by my emotional and
physical condition. The drugs weren't working properly and I was
having clinical problems. By now I was living alone in a Council flat
which was a shock to my system, and I was in love with someone who
was rapidly falling out of love with me. It seemed an excellent idea
to return to photography, at the very least it was one thing I could do
well, and who knew, it might even have a therapeutic effect.

I decided to return to basics. I got the old jobbing Hasselblad out and
went back to the darkroom. It worked. I did have a skill, a craft, by
now embedded in me, and it still gave me an enormous amount of joy
watching hand made prints emerge from the processor. I felt I had
made a big first step on the road to recovery.

The project was an interpretation of HIV and its effects on my body,
and a map of my local context, South London, as a focal point of
attitudes towards HIV survivors and also their treatments. It had
two parallel narratives; one the contemporary gay scene (seen in
terms of the architecture of venues), the other my own medicalisa-
tion. The current explosion of sexuality on the London gay scene
seems to have converged with the loss of politics around the gay body.

I was able to get over a very particular personal hurdle, that of exhibiting pictures of my own body, dealing with its age and its illnesses. The first time I saw the photographs on the wall I had to be on my own as I wasn't sure how I'd react to them, but once I saw them, I realised that they were a cultural product and quite distanced from the reality of being me.

The show, a two hander with Ajamu, went down well and since then I have been compelled to make more pictures. If I were to die of this disease then the best legacy I could leave would be pictures.

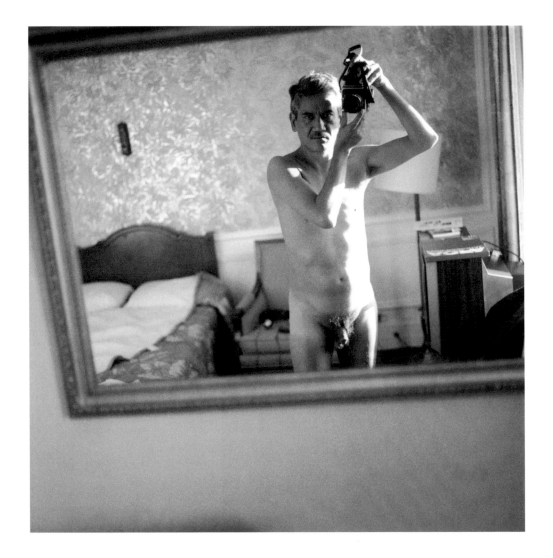

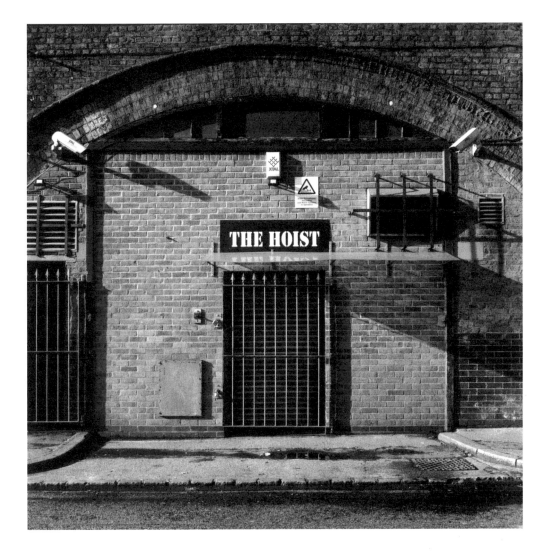

BLOOD

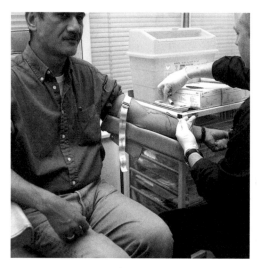

FORT

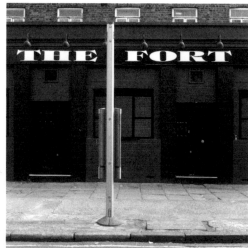

BABE

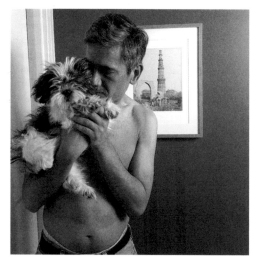

FIST

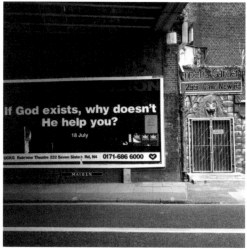

SHROUD

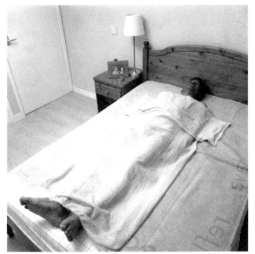

PLEASUREDROME

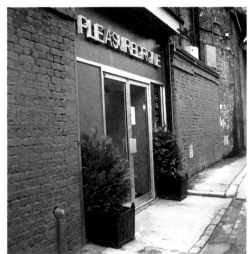

CHRISTMAS

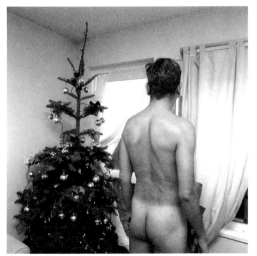

SUBSTATION

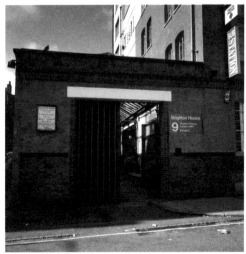

FROM HERE TO ETERNITY

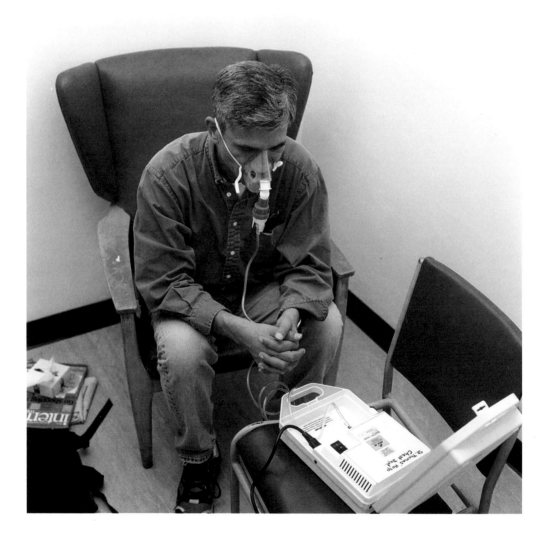

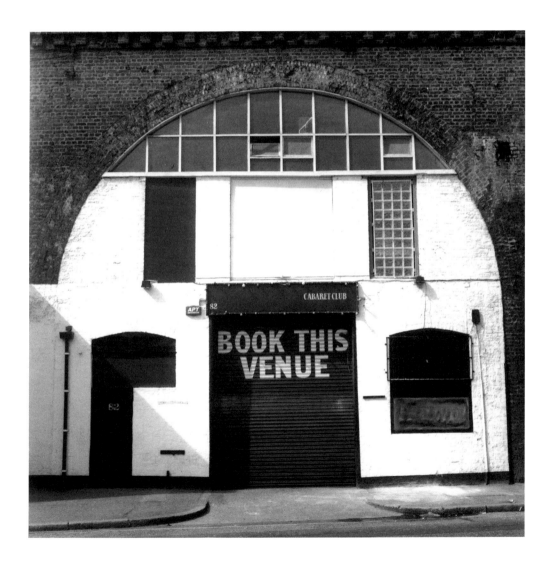

Homelands

At the end of 1999, an opportunity arose to make a more substantial body of work over a longer period of time with the support of an academic grant. I decided to continue with the HIV theme and the idea of visual juxtaposition that I had tried out in From Here to Eternity. I wanted to connect the places that I had an affinity with: Northern India, the North Eastern part of the USA and the Eastern part of Canada. These places had all been homes to me over the years and I wanted to make work about the journeys travelled between them.

I began to make photographs in all these locations with a view to presenting them in oppositional pairs. The initial pieces confronted the West, as the current context of my life, with India at a slight remove. Although I have strong ties to India, it has acquired a mythical distance. I hardly ever get to experience it for real, and I set out to explore my memory of it.

The making of the Indian photographs became a health issue for me. Being immune suppressed and travelling in an environment where local viruses might pose a high risk was not popular with friends and family, both here and in India. Couldn't I do this virtually? Well, no. I did get a bug, and one that remains a medical mystery. Not since the Tilonia story had I had made shooting trips to India and it was very exciting to work there again. I followed a very personal itinerary, to familiar places in Delhi, my old home and school, and taking the train trip back to my father's village (where I have inherited some property, and where the rural Indian pictures were made).

Initial experiments in binary oppositions - the West versus India, inside versus outside - seemed formulaic. In the end, the East West theme continued but the other parameters became more spontaneous and intuitive. The choices of each image then became more flexible, sometimes governed by formal concerns of colour and line, sometimes because of specific information in the pictures.

What I wanted in the end was a sense of the landscape of these different worlds.

This was the landscape that the HIV virus was travelling in. I've often read about it as clinical history, its much-contested origins, its transmission, and the fear it aroused in people - being both invisible and lethal. However, it was either visualised clinically, as an image of a virus, or in terms of the devastating physical effects it has on people. HIV has a look. But I wanted to make benign pictures of landscapes through which a terrifying virus was spreading. My presence in the landscape is ambivalent, since I am a carrier. Researching the issue in India, I became acutely aware that the scale of the region and the ramifications of the epidemic were going to be too vast to encompass in the project. In the work, I narrowed my focus to a 'conversation' between me as someone living in the West and me as if I had never left India.

I settled for a large scale series of photographs, 'geographies' of home, accompanied by a videotape representing a journey between them - a personal travelogue within which a discussion takes place about being gay, Indian and HIV positive. So while the narrative remains close to the body, to me, for the first time in a while, the photography has been liberated to explore the world outside.

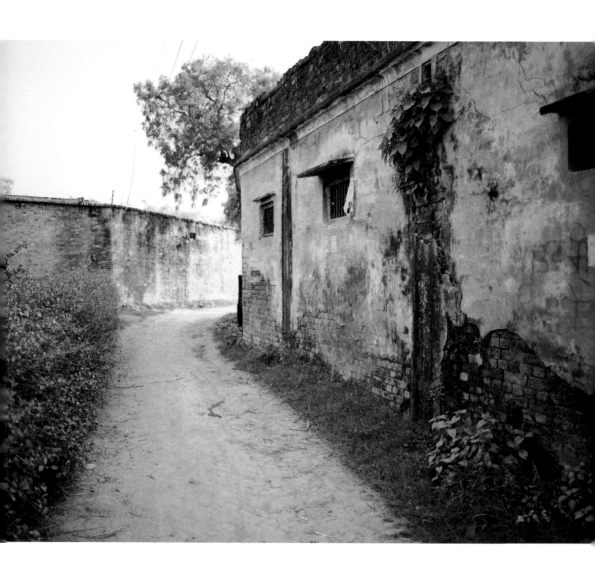

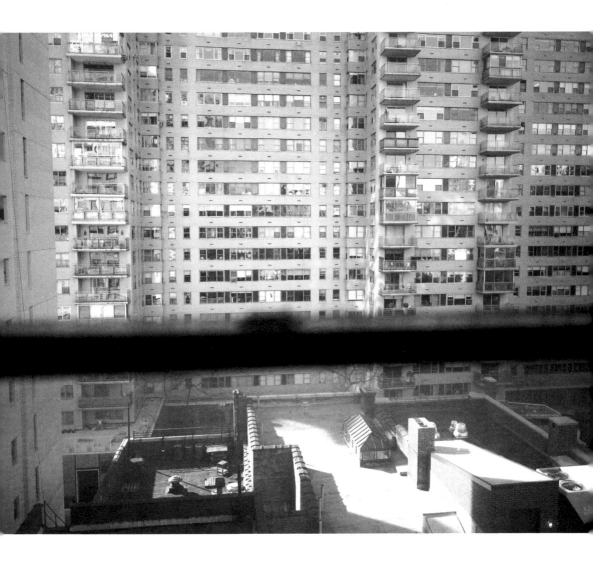

HOMELANDS

QUEENS, NEW YORK / LAMBETH, LONDON

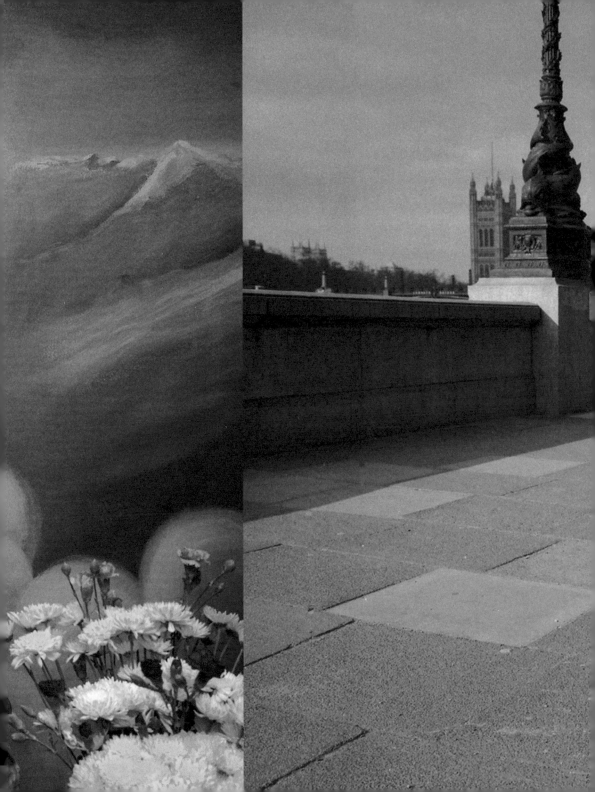

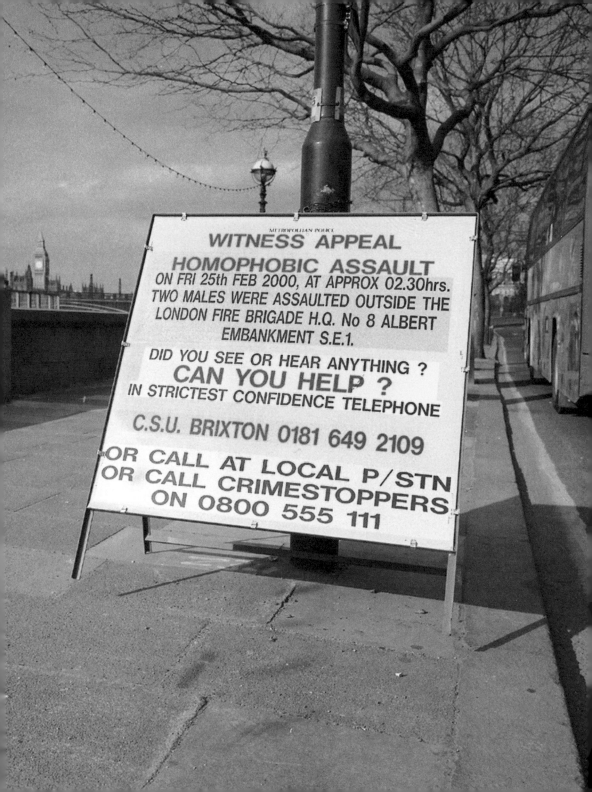

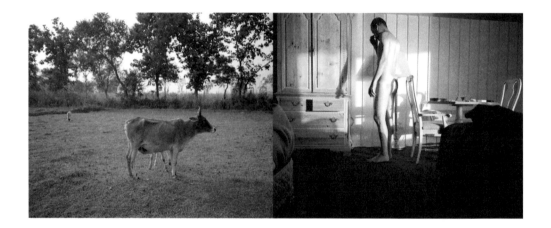

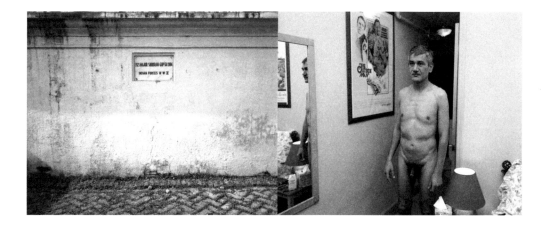

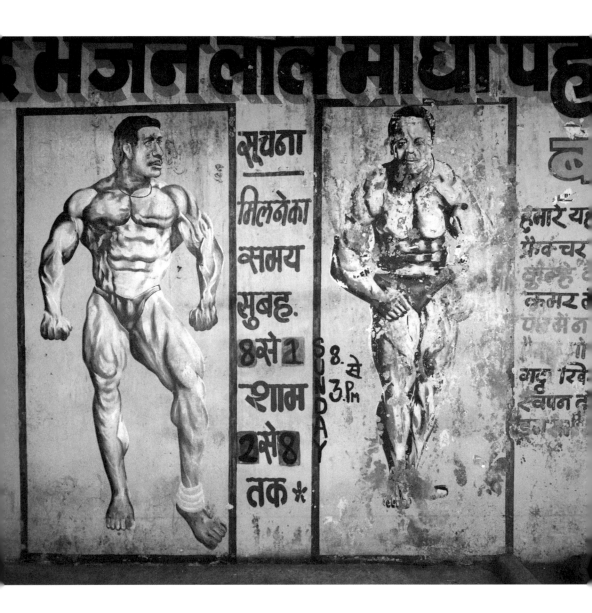

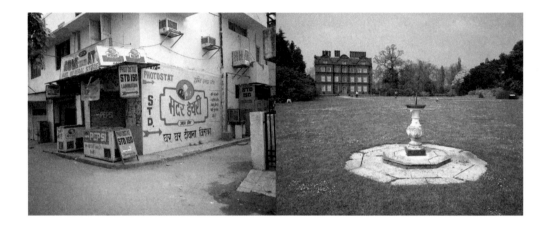

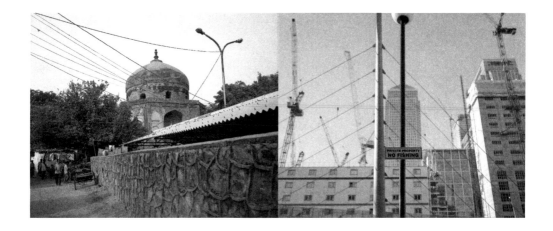

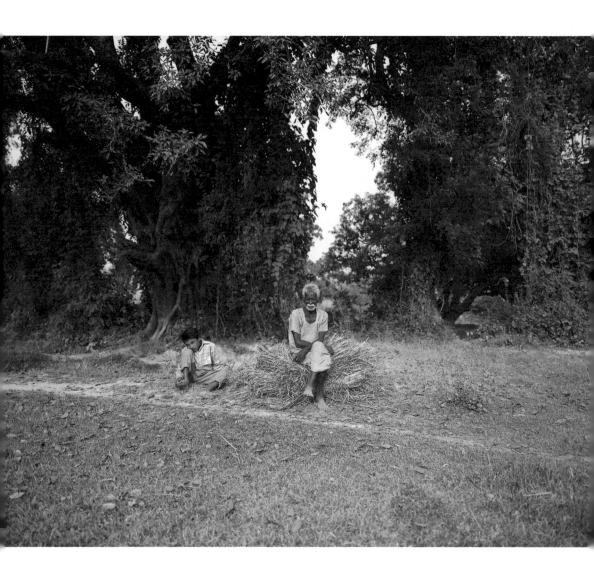

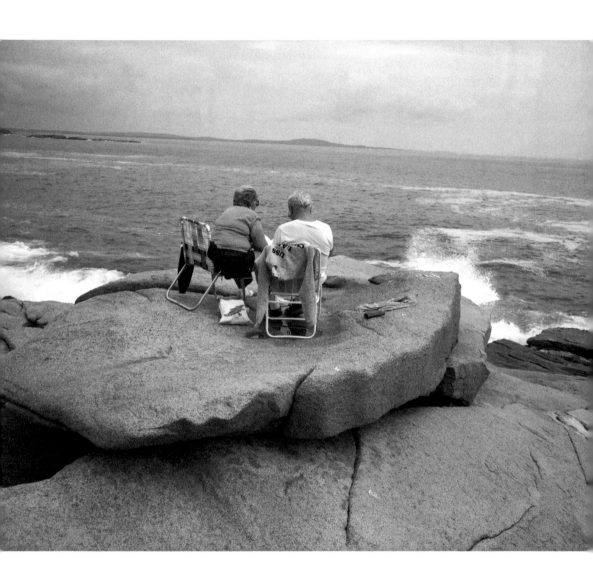

HOMELANDS

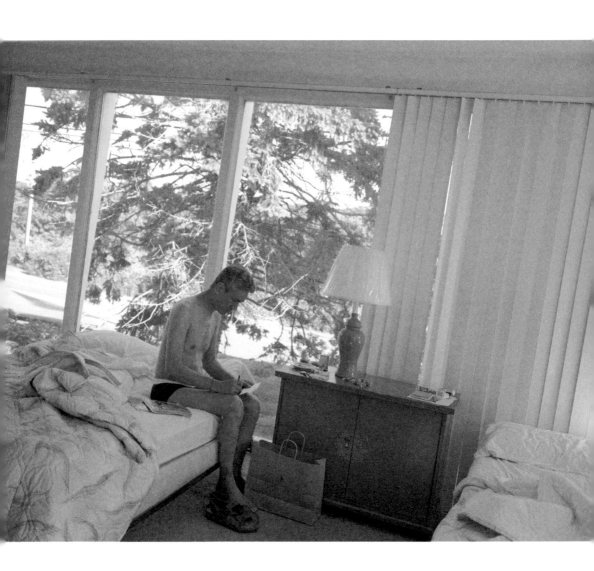

HOMELANDS

BETHLEHEM, CHURCH OF THE NATIVITY

Christmas Joy

HOMELANDS

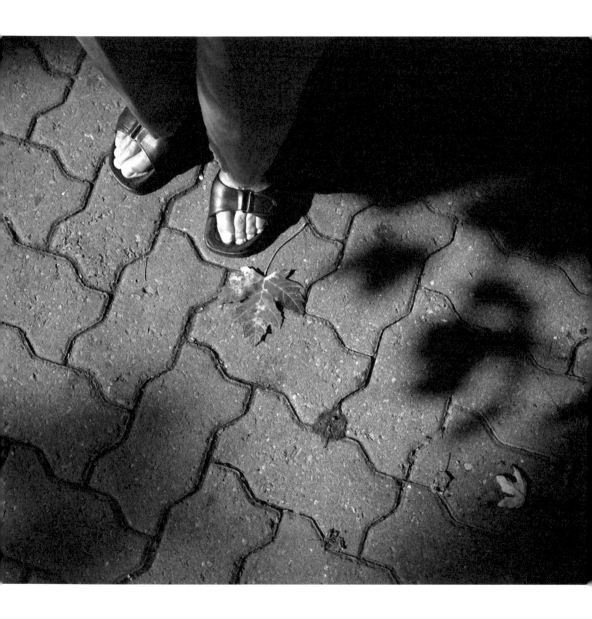

HOMELANDS

SERIES NOTES

TILONIA

50 CIBACHROMES AND 10 SILVER
GELATIN PRINTS (20"X16",
24"X20"), 11 TEXT PANELS
AND TAPE-SLIDE PROGRAMME
SUPPORTED BY THAMES TV BURSARY
AND THE SOCIAL WORK & RESEARCH
CENTRE, TILONIA, RAJASTHAN
FIRST EXHIBITED AT THE
COMMONWEALTH INSTITUTE, LONDON,
1984

TEN YEARS ON

30 SILVER GELATIN PRINTS (15"X19")
COMPLETED IN 1985, UNEXHIBITED

SOCIAL SECURITY

20 C AND R TYPE PRINTS (42"X29.5")
AND ACCOMPANYING TEXT PANELS
COMMISSIONED BY CANADA HOUSE,
LONDON
FIRST EXHIBITED AT THE SHOWROOM,
LONDON, 1988

REFLECTIONS OF THE BLACK
EXPERIENCE

10 SILVER GELATIN PRINTS (15"X19")
COMMISSIONED BY THE RACE EQUALITY
UNIT, GREATER LONDON COUNCIL AS
PART OF THE BLACK EXPERIENCE
PROGRAMME
FIRST EXHIBITED AT THE BRIXTON ART
GALLERY 1986, CURATED BY MONIKA
BAKER

EXILES

12 C TYPE PRINTS (19"X19") AND TEXT
COMMISSIONED AND EXHIBITED BY THE
PHOTOGRAPHERS' GALLERY, LONDON,
AS PART OF BODY POLITICS,
CURATED BY ALEXANDRA NOBLE, 1987
CATALOGUE PUBLISHED BY TEN.8,
ISSUE NO. 25, 1987

'PRETENDED' FAMILY
RELATIONSHIPS

12 C TYPE AND SILVER GELATIN PRINTS
(24"X36"), WITH POEMS BY STEPHEN
DODD
FIRST EXHIBITED AT RANDOLPH STREET
GALLERY, CHICAGO, 1989

TRESPASS, PART 1

8 INK-JET PRINTS ON PAPER
(38" HIGH, VARIABLE LENGTH)
COMMISSIONED BY TROPHIES OF EMPIRE
FIRST EXHIBITED FERENS ART
GALLERY, HULL AND ARNOLFINI,
BRISTOL, 1992
CATALOGUE PUBLISHED BY
CONTEMPORARY ART GALLERY,
VANCOUVER, EDITED BY KEITH

WALLACE WITH ESSAYS BY DAVID A
BAILEY AND EUGENIO VALDEZ

TRESPASS, PART 2

10 INK-JET PRINTS ON PAPER
(39.5"X29.5")
GRANT AIDED BY LONDON ARTS
FIRST EXHIBITED IN THEY CALL IT
LOVE CURATED BY FRANK WAGNER
FOR NGBK, BERLIN, 1993

TRESPASS, PART 3

10 INK-JET PRINTS ON PAPER
(39.5"X29.5")
COMMISSIONED AND EXHIBITED BY
FOCAL POINT GALLERY (THE ESSEX
FELLOWSHIP IN PHOTOGRAPHY),
SOUTHEND, 1995
SERIES CATALOGUE PUBLISHED BY
AUTOGRAPH, LONDON

FROM HERE TO ETERNITY

12 C TYPE PRINTS (19"X19") EACH IN
AN EDITION OF 5; LAMDA PRINTS
(48"X48") IN AN EDITION OF 1
COMMISSIONED AND PUBLISHED BY
AUTOGRAPH, LONDON WITH AN ESSAY
BY EMMANUEL COOPER
FIRST EXHIBITED AT STANDPOINT
GALLERY, LONDON 1999

HOMELANDS

20 LAMDA PRINTS (30"X59"), EACH IN
AN EDITION OF 5
FUNDED BY AN AHRB FELLOWSHIP IN
THE CREATIVE AND PERFORMING
ARTS, AT THE ENGLISH DEPARTMENT
OF THE UNIVERSITY OF
SOUTHAMPTON, 2000-02
FIRST EXHIBITED AT ST PAUL'S
SCHOOL, LONDON AND ADMIT ONE
GALLERY, NEW YORK 2001

SELECTED EXHIBITIONS

SOLO EXHIBITIONS

2004 HABITAT CENTRE, NEW DELHI
2004 STEPHEN BULGER GALLERY,
TORONTO
2003 JOHN HANSARD GALLERY,
SOUTHAMPTON, UK
2001 HOMELANDS, ADMIT ONE GALLERY,
NEW YORK
2001 HOMELANDS, ST PAUL'S SCHOOL,
LONDON
2000 FROM HERE TO ETERNITY,
GALLERY SEPULCHAR, MANILA
1999 PHOTOWORKS 1987-1999
ADMIT ONE GALLERY, NEW YORK
1997 TRESPASS 3, BEDFORD HILL
GALLERY, LONDON
1997 TRESPASS 3, PORTFOLIO
GALLERY, EDINBURGH, UK
1996 TRESPASS 3, YYZ, TORONTO
1995 TRESPASS 3, FOCAL POINT
GALLERY, SOUTHEND, UK
1994 CONTEMPORARY ART GALLERY,
VANCOUVER
1991 FILM IN THE CITIES, ST PAUL,
MN
1991 THEATRE WORKSHOP, EDINBURGH
FESTIVAL, UK
1988 SOCIAL SECURITY, THE
SHOWROOM, LONDON
1986 LEICA GALLERY, WETZLAR,
GERMANY
1986 SOUTH HILL PARK, BRACKNELL,
UK
1984 MUSEUM & ART GALLERIES,
LEICESTER, UK
1984 MUSEUM & ART GALLERIES,
NOTTINGHAM, UK
1984 UN INTERNATIONAL MARITIME
ORGANISATION, LONDON
1983 COMMONWEALTH INSTITUTE,
LONDON
1980 INDIA INTERNATIONAL CENTRE,
NEW DELHI

GROUP EXHIBITIONS

2003 FACES, SEPIA INTERNATIONAL,
NEW YORK
2003 HAMMER SIDI GALLERY, ARCO,
MADRID
2002-03 SELF EVIDENT, TATE
BRITAIN, LONDON
2002 FACING AIDS, INTERNATIONAL
AIDS CONFERENCE, BARCELONA
2001 TYPICAL MEN, DJANOGLY ART
GALLERY, NOTTINGHAM & TOURING
2000 URBAN FUTURES, UNIVERSITY OF
THE WITWATERSRAND, JOHANNESBURG
1999 BROKEN WINDOWS, FRACTURED
MIRRORS, PHOTOGRAPHIC RESOURCE
CENTRE, BOSTON
1999 BODIES OF RESISTANCE, REAL
ART WAYS, HARTFORD CT & TOURING

1999 *CROWN JEWELS*, KAMPNAGEL [K3],
 HAMBURG & NGBK, BERLIN
1999 *SUNIL GUPTA & AJAMU*,
 STANDPOINT GALLERY, LONDON
1999 *OOOZEROZEROZERO*, WHITECHAPEL
 ART GALLERY, LONDON
1999 *MAKING VISIBLE THE INVISIBLE*,
 DOMINION ARTS CENTRE, SOUTHALL,
 LONDON
1997/98 *OUT OF INDIA*, QUEENS
 MUSEUM OF ART, NEW YORK
1997/98 *TRANSFORMING THE CROWN*,
 CARIBBEAN CULTURAL CENTRE, NEW
 YORK
1994 *HAVANA BIENNALE*, CUBA; LUDWIG
 FORUM, AACHEN, GERMANY
1993 *THEY CALL IT LOVE*, NGBK,
 BERLIN
1992/93 *TROPHIES OF EMPIRE*
 ARNOLFINI, BRISTOL & FERENS ART
 GALLERY, HULL, UK
1992 *FINE MATERIAL FOR A DREAM*,
 HARRIS MUSEUM, PRESTON & TOURING
 [HULL, OLDHAM]
1992 *HOW DO I LOOK?* INSTITUTE OF
 MODERN ART, BRISBANE & TOURING
1992 *QUEER LANDSCAPE*, EVERGREEN
 STATE COLLEGE, OLYMPIA, WA
1992 *DIS/ORIENT*, UIC GALLERY 400,
 CHICAGO
1991 *SHOCKS TO THE SYSTEM*, THE
 SOUTH BANK CENTRE, LONDON
1990 *POST MORALITY*, KETTLE'S YARD,
 CAMBRIDGE, UK
1990 *AUTOPORTRAITS*, CAMERAWORK,
 LONDON
1990 *ECSTATIC ANTIBODIES*,
 IMPRESSIONS GALLERY, YORK, UK
 [TOUR]
1989 *FABLED TERRITORIES*, CITY ART
 GALLERY, LEEDS, UK [TOUR]
1989 *PARTNERS IN CRIME*,
 CAMERAWORK, LONDON
1989 *THROUGH THE LOOKING GLASS*,
 BARBICAN ART GALLERY, LONDON
1988 *MONOLOGUE/DIALOGUE*, RANDOLPH
 STREET GALLERY, CHICAGO
1987 *THE BODY POLITIC*, THE
 PHOTOGRAPHERS' GALLERY, LONDON
 [TOUR]
1986 *DARSHAN*, GLC/ CAMERAWORK,
 LONDON
1986 *THE BLACK EXPERIENCE*, BRIXTON
 ART GALLERY, LONDON
1985 *RIVERSIDE OPEN*, RIVERSIDE
 STUDIOS, LONDON
1985 *STAYING ON*, THE
 PHOTOGRAPHERS' GALLERY, LONDON
1983 *NEW CONTEMPORARIES*, ICA,
 LONDON
1982 *THE LIVING ARTS*, SERPENTINE
 GALLERY, LONDON
1980 *SALFORD '80*, SALFORD, UK

PUBLICATIONS

BOOKS
EXILES, SELF PUBLISHED, LONDON
 2000
FROM HERE TO ETERNITY, SELF
 PUBLISHED, LONDON 2000
SUNIL GUPTA/TRESPASS, AUTOGRAPH,
 LONDON 1998
DISRUPTED BORDERS, [ED] RIVERS
 ORAM PRESS, LONDON & BOSTON 1993
AN ECONOMY OF SIGNS, [ED] RIVERS
 ORAM PRESS, LONDON & BOSTON 1990
*ECSTATIC ANTIBODIES: RESISTING THE
 AIDS MYTHOLOGY*, [ED WITH TESSA
 BOFFIN], RIVERS ORAM PRESS,
 LONDON 1990

ARTICLES
SUNIL GUPTA AT ADMIT ONE GALLERY
 [NEW YORK, JAN 2000] REVIEWED
 IN THE NEW YORK TIMES, FLASH
 ART, ART IN AMERICA, INDIA TODAY
SUNIL GUPTA & AJAMU, TIME OUT
 LONDON, OCTOBER 6-13, 1999
STRUKTURVERÄNDERUNGEN, FORUM DES
 ARTS FRANCO-ALLEMAND, CHATEAU
 DE VAUDRÉMONT, FRANCE 1999
 [CATALOGUE]
OUT OF INDIA, QUEENS MUSEUM OF ART,
 NEW YORK 1998 [CATALOGUE]
TRANSFORMING THE CROWN, CARIBBEAN
 CULTURAL CENTRE, NEW YORK 1998
 [CATALOGUE]
*GETTING THEM BETWEEN THE EYES:
 AN INTERVIEW WITH SUNIL GUPTA*,
 ANTONIA CARVER, ART ASIA
 PACIFIC, ISSUE 16, SYDNEY
*MEMORY, HISTORY AND LANGUAGE:
 THE WORK OF DOMINIQUE BLAIN*,
 CATALOGUE ESSAY, ARNOLFINI,
 BRISTOL 1997
CULTURE WARS: RACE AND QUEER ART,
 EDS. PETER HORNE AND REINA
 LEWIS, ROUTLEDGE, LONDON 1996
*CURATING THE "NEW INTERNATIONAL"
 VISUAL ARTS*, ESSAY IN NAMING A
 PRACTICE: CURATORIAL STRATEGIES
 FOR THE FUTURE, ED. PETER WHITE,
 WALTER PHILIPS GALLERY, THE
 BANFF CENTRE, CANADA 1996
*COCKS AND OTHER CONTRADICTIONS:
 THE WORK OF ROBERT MAPPLETHORPE*,
 ESSAY IN PORTFOLIO MAGAZINE,
 NUMBER 24, DECEMBER 1996
SUNIL GUPTA, CREATIVE CAMERA,
 ISSUE 339, APRIL/MAY 1996
TRESPASS 2, EXPOSURE, VOL. 29,
 NO. 2/3, DALLAS 1994
TRESPASS 1, CONTEMPORARY ART
 GALLERY, VANCOUVER 1995
 [CATALOGUE]
CULTURAL REVOLUTION, ARTISTS
 NEWSLETTER, FEBRUARY 1995

INDIA POSTCARD IN QUEER LOOKS,
 JOHN GREYSON, MARTHA GEVER,
 PRATIBHA PARMAR, EDS. ROUTLEDGE,
 NEW YORK & LONDON 1993
INTRODUCTION IN DISRUPTED BORDERS,
 ED. SUNIL GUPTA, RIVERS ORAM
 PRESS 1993
BLACK BOYS, SHOOTING BACK, PERTH
 INSTITUTE OF CONTEMPORARY ART,
 PICA PRESS, PERTH, AUSTRALIA
 1992
*COWBOYS & INDIANS: DANCING WITH
 HOLLYWOOD*, BAZAAR MAGAZINE
 NO 17 1991
*PHOTOGRAPHY, SEXUALITY & CULTURAL
 DIFFERENCE: THE EMERGENCE OF
 BLACK LESBIAN AND GAY IDENTITIES
 IN THE UK*, SF CAMERAWORK, SAN
 FRANCISCO 1990
*NO SOLUTION IN ECSTATIC
 ANTIBODIES*, TESSA BOFFIN & SUNIL
 GUPTA, EDS.; RIVERS ORAM PRESS,
 1990
HOMOSEXUALITIES-PART I, TEN.8,
 ISSUE 31, 1988
*BLACK, BROWN & WHITE IN COMING ON
 STRONG*, EDS. SHEPHERD & WALLIS,
 ALLEN & UNWIN, 1989
*COINCIDENTAL COMMISSIONS IN WORK
 STATIONS*, ANNA FOX, CAMERAWORK,
 1988
FROM INDIA WITH LOVE, LESBIAN & GAY
 SOCIALIST, WINTER 1987
*NORTHERN MEDIA/SOUTHERN LIVES IN
 PHOTOGRAPHY/POLITICS 2*, EDS.
 WATNEY, SPENCE & HOLLAND,
 METHUEN 1987
THE RHETORIC OF AIDS, WITH SIMON
 WATNEY, SCREEN, JAN./FEB. 1986
CAMERAWORK, THE BRITISH JOURNAL
 OF PHOTOGRAPHY, 1986
DESIRE & BLACK MEN, TEN.8, 1986
 [REPRINTED IN CRITICAL DECADE,
 TEN.8 PUBLICATION 1992]
LOVERS: TEN YEARS ON, CREATIVE
 CAMERA, 1986
CLOSETED BY CASTE AND CLASS,
 INSIDE ASIA, 1985
THE HIDDEN INDIA, GAY TIMES, 1984
TEN YEARS ON, SQUARE PEG, 1984
BEST FOOT FORWARD, SOUTH: THE
 THIRD WORLD MAGAZINE, 1983
*THEY DARE NOT SPEAK ITS NAME IN
 DELHI*, THE GUARDIAN, NOVEMBER 26
 1982

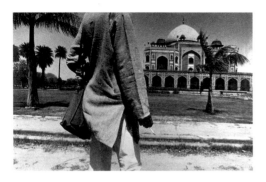

This book is dedicated to Saleem Kidwai who through his courage and tenacity over the last twenty five years showed me that it was possible to be a good gay man and an Indian at the same time regardless of whether we were in Montreal, New York, London or New Delhi. That it was possible to overcome fear and put one's sexuality in the public arena to make history. Sunil Gupta, March 2003